IMAGES
*of America*

BROOKFIELD ZOO AND THE
CHICAGO ZOOLOGICAL SOCIETY

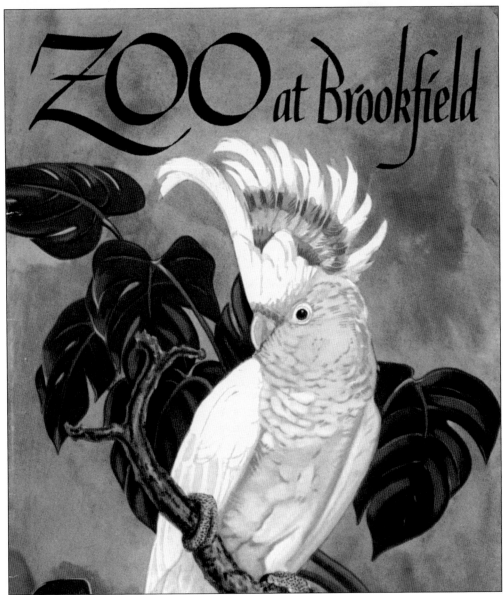

# ZOO at Brookfield

For five decades, Brookfield Zoo published annual illustrated guidebooks that cost 25¢. There was always a brightly colored front cover illustration and a convenient, easy-to-follow zoo map on the back. This 1951 cover by Karl Plath, the zoo's first curator of birds and an accomplished artist, showcases Cookie, a pink and white Major Mitchell's cockatoo from the original 1934 collection. Cookie is alive and well at the time of this printing. His exact age is unknown, but he is believed to be at least 77 years old. Originally from Australia, which is home to his species, he has become one of Brookfield Zoo's most famous animals. He long ago acquired quite a loyal following among zoo visitors, "Cookie's groupies," who come specifically to see him in the Perching Bird House, and he even receives fan mail.

*On the cover*: This majestic image of a polar bear at sunrise was featured on a Chicago Zoological Park postcard in 1934. (Courtesy of the Chicago Zoological Society Archives.)

IMAGES
*of America*

# BROOKFIELD ZOO AND THE
# CHICAGO ZOOLOGICAL SOCIETY

Douglas Deuchler and Carla W. Owens

ARCADIA
PUBLISHING

Published by Arcadia Publishing
Charleston SC, Chicago IL, Portsmouth NH, San Francisco CA

Printed in the United States of America

Library of Congress Control Number: 2008943877

For all general information contact Arcadia Publishing at:
Telephone 843-853-2070
Fax 843-853-0044
E-mail sales@arcadiapublishing.com
For customer service and orders:
Toll-Free 1-888-313-2665

Visit us on the Internet at www.arcadiapublishing.com

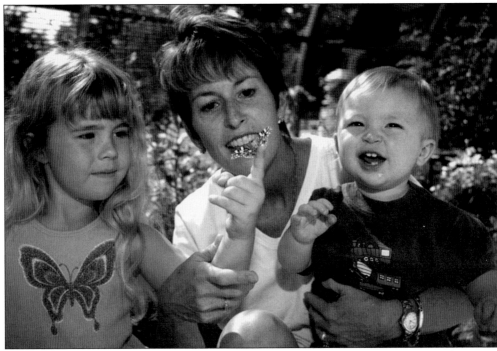

This recent photograph captures Trish Long and family's delight in encountering the insect and plant life in Butterflies! Fostering positive emotional experiences with the natural world is one important way the Chicago Zoological Society fulfills its mission to inspire conservation leadership by connecting people with wildlife and nature. This commitment to conservation, first expressed under the early leadership of zoo director Edward Bean, is evident today in the organization's many educational and outreach programs. (Photograph by Jim Schulz.)

# CONTENTS

Acknowledgments                                    6

Introduction                                       7

1.   In the Beginning                              9

2.   Success Story                                29

3.   Midcentury Maturity                          55

4.   Changes and Challenges                       83

5.   New Directions                              111

# ACKNOWLEDGMENTS

We wish to thank the Chicago Zoological Society for access to staff, archives, and personal files in order to make this project a reality. We are especially grateful to Dr. Stuart D. Strahl, president, Chicago Zoological Society, and Alejandro Grajal, senior vice president, conservation, education, and training, for the opportunity to document the rich history of Brookfield Zoo.

A special thank-you to all the Animal Programs staff for sharing and contributing their time and expertise.

We also appreciate the following individuals for their cooperation and support: Melissa Birks, Sally France, Breanne Geery, Jerry Janiak, Laurie Janiak, Julee Long, Jill Lundstrom, Tim Machony, Sandra Polis, Ron Ream, Alex Schmidt, Alice Shallbetter-Gardner, Dorothy Shortle, Connie Thome, Ryan Topf, Mariann Vilcek, and Jerry Wickman.

We are grateful to Kit Ketchmark, director, Brookfield Historical Society, for the loan of its files of newspaper clippings and vintage zoo brochures.

We would especially like to express our appreciation to Chicago Zoological Society photographer Jim Schulz for generously sharing his fine work with us for this project.

We appreciate Debbie Johnson, registrar, for providing historical animal record information.

We would like to thank Catherine Murrell at the Chicago Zoological Society for her thorough and supportive editing.

We would like to acknowledge our spouses Nancy Deuchler and Matthew Owens for continued support throughout the process.

Unless otherwise noted, all images are courtesy of the Chicago Zoological Society Archives.

# INTRODUCTION

The Chicago Zoological Society's Brookfield Zoo celebrates its 75th anniversary in 2009. Located 14 miles west of downtown Chicago, it is open 365 days a year.

The zoo's history began nearly a decade and a half before it opened. In 1919, Chicago socialite Edith Rockefeller McCormick offered the Forest Preserve Commissions of Cook County a large tract of land on which to establish a zoo. Her gift was augmented by the Forest Preserve District of Cook County to become a 216-acre "zoological garden" with plenty of growing room.

The Chicago Zoological Society was originated in 1921 by a group of public-spirited citizens. John T. McCutcheon, *Chicago Tribune* cartoonist, was its first president. By contract between the society and the Forest Preserve District of Cook County, the zoo was constructed and continues to be maintained and operated by the society.

In 1922, groundbreaking took place. After Cook County residents approved a zoo tax in 1926, serious construction finally began. The layout and buildings were designed by well-known Chicago architect Edwin H. Clark. Construction abruptly ceased, however, with the 1929 stock market crash. To a large extent, the zoo was built by Civil Works Administration labor during the darkest days of the Great Depression.

Brookfield Zoo finally opened, behind schedule and without all the exhibits finished, on July 1, 1934. It gained international recognition for using moats instead of bars and cages to separate animals from visitors. Among the outstanding early animal attractions featured at Brookfield Zoo were the giant pandas—Su-Lin, Mei-Mei, and Mei-Lan—exhibited from 1937 to 1953. Perhaps the most famous resident was Ziggy or Ziegfeld (1920–1975), a six-and-a-half-ton bull elephant that acquired a cult following in his later years.

Although the development of the zoo was interrupted by World War II, the Chicago Zoological Society expanded its size in the postwar period with the construction of the Veterinary Hospital (1952), Children's Zoo and Farm (1953), and the famous Roosevelt Fountain in the center of the park (1954). The zoo built the nation's first inland dolphinarium in 1961 and created Tropic World, a huge indoor immersion rainforest (complete with waterfalls and thunderstorms) in the 1980s—another first of its kind.

In the early 21st century, the zoo is a leader in a variety of conservation programs. In 2008, the animal collection numbered 382 species and 3,831 specimens. Attendance was over two and a half million visitors.

The photographs in this volume come from a wide variety of sources, public and private. We hope that the 237 images and accompanying text allow the reader to experience the thrilling adventure that characterized the evolution of Brookfield Zoo from its early beginnings down to its exciting new directions in the 21st century. Join us as we celebrate this rich history.

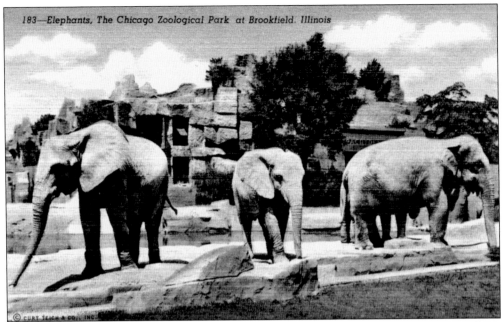

183—Elephants, The Chicago Zoological Park at Brookfield, Illinois

© CURT TEICH & CO., INC.

Picture postcards were the e-mail of the first half of the 20th century. The 1934 image above shows a trio of African elephant females. The ears of African elephants are shaped much like a map of the continent of Africa. The three reticulated giraffes, a male and two females, featured on the 1936 picture postcard below were 10 months old when they arrived at Brookfield Zoo. They originally lived at an elevation of 5,000 feet on the northern slope of Mount Meru in Africa. Each has a unique pattern of large brown spots separated by cream-colored lines—much like human fingerprints. Note the Indian peacock (left) fanning out his train feathers. Since the zoo opened, peafowl have roamed the park freely.

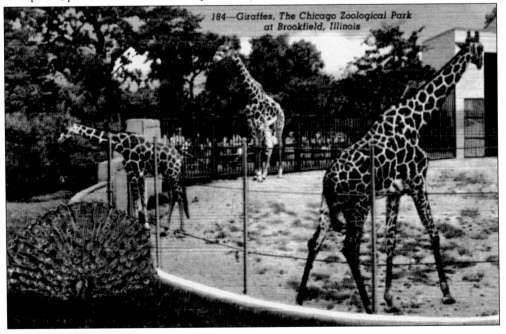

184—Giraffes, The Chicago Zoological Park at Brookfield, Illinois

# One

# IN THE BEGINNING

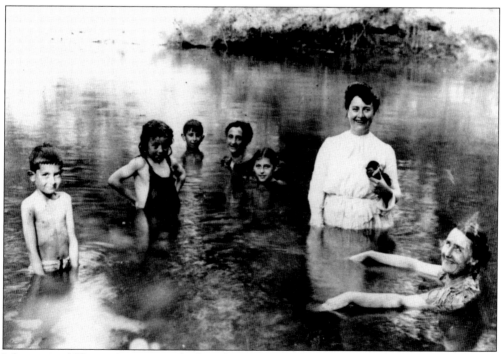

Like many of Chicago's western suburbs, what eventually became the town of Brookfield started out as a wilderness inhabited by Fox and Potawatomi Native Americans who traveled up and down Salt Creek by canoe. During the early 19th century, white pioneers ran a fur trading post here. This photograph, taken in 1903, shows some local bathers enjoying a morning dip in a stretch of Salt Creek—now part of the western edge of Brookfield Zoo.

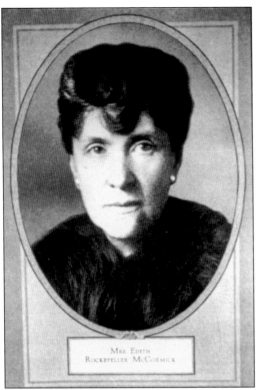

Mrs. Edith
Rockefeller McCormick

The Chicago Zoological Society was founded in 1921, following a gift of 83 acres of land from Chicago socialite Edith Rockefeller McCormick (1872–1932), daughter of industrialist John D. Rockefeller and said to be the richest woman in the nation during the 1920s. McCormick donated the land to the Forest Preserve District of Cook County purposely for a large modern zoo similar to the innovative barless zoos she had enjoyed in Europe.

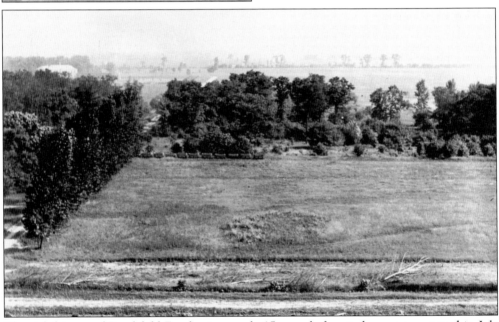

The rich history of Brookfield Zoo begins nearly 15 years before its huge gates opened in July 1934. Seen here is part of Edith Rockefeller McCormick's property that had been a real estate failure. Instead of a suburban building boom as she had anticipated, for several years after World War I there was an economic slump. Only a very few customers had purchased lots in her subdivision.

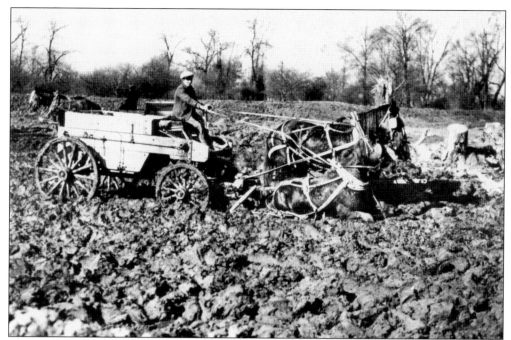

Critics of the benefactress were cynically convinced McCormick's debt of $20,500 for back taxes on the property was the true reason for her generosity. Nevertheless, following her gift of land for a zoo, the Forest Preserve District of Cook County responded by adding another 98 acres. This vast combined tract provided the Chicago Zoological Garden, as it would soon be dubbed, with lots of growing room.

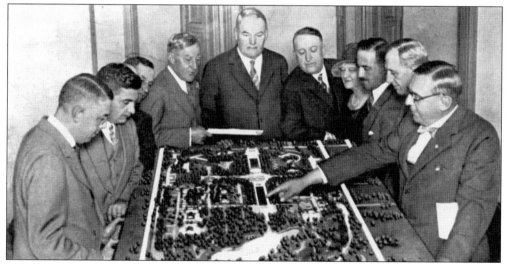

Many officers and trustees of the Chicago Zoological Society are examining a model of the proposed zoo on September 27, 1926. The man on the far left is architect Edwin H. Clark, who designed all the original buildings. The individual pointing to the model, on the far right, is Anton J. Cermak (1873–1933), president of the Cook County Board and chairman of the Cook County Democratic Party at the time. On Cermak's right is cartoonist and Chicago Zoological Society president John T. McCutcheon. Seven years later, Cermak, then mayor of Chicago, was killed by an assassin's bullet intended for Pres. Franklin D. Roosevelt.

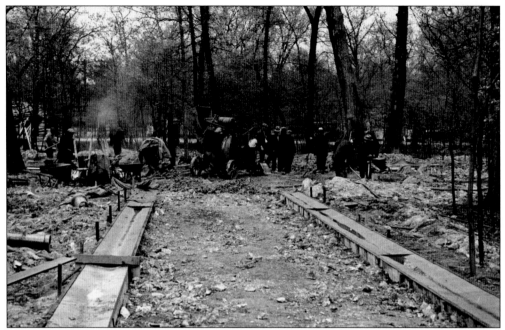

Fewer than two dozen trees had to be removed when the walkways and paved paths were constructed in 1927 and 1928. This photograph, showing the heavily wooded western section of the zoo property, looks much like the region would have appeared 200 years earlier, just before the arrival of the first French fur traders.

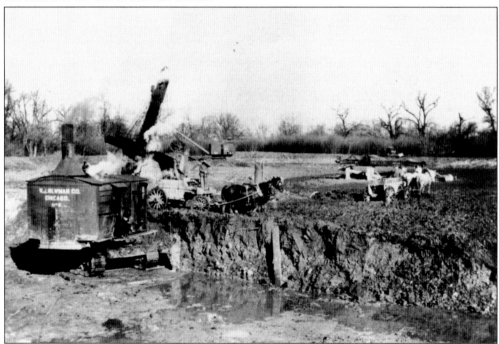

The steam tractor and shovel loader, pictured here in 1927, are digging trenches and removing dirt. Although few trees were actually removed from the vast tract, massive clearing by horse and wagon had to be completed before any actual building construction could begin.

The early development of the zoo was set back by a failed tax initiative. Planning began in earnest after a special "zoo tax" narrowly passed on a 1926 ballot. The Reptile House was the first completed structure. In 2005, most of the reptiles were moved to the Feathers and Scales building across the Formal Pool. The Reptile House was visited by millions for over 70 years.

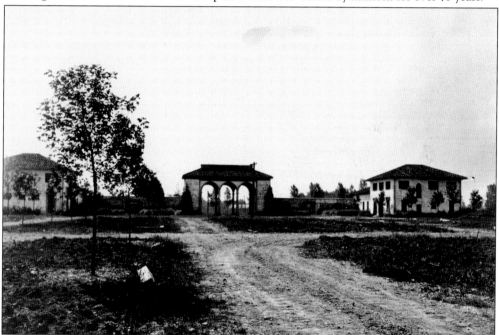

Looking south from the central circle (27 years before the construction of the Roosevelt Fountain), this photograph is facing the South Gate, still under construction in 1927. Edwin H. Clark, a well-known Chicago architect, designed the original buildings in a blend of classical Greek and Renaissance Italian styles. There were brick walls painted a cream color, gray stone trim, and red tile roofs. Clark's overall plan called for both naturalistic exhibits (rocklike grottoes enclosing wide yards), and stately, formal buildings arranged around the central axis of landscaped malls.

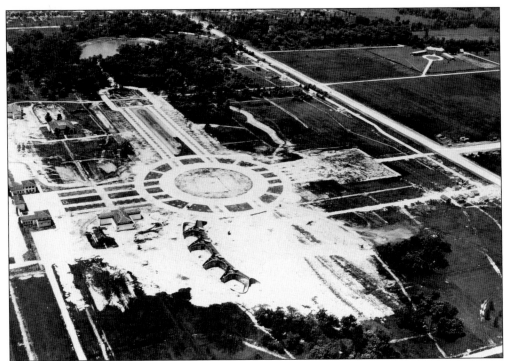

The Chicago Zoological Garden, as it was known initially, was laid out in the popular cruciform style around a circular centerpiece. This 1927 aerial photograph looks west. Zoo planners hoped to someday build a large fountain as a centerpiece to the grounds. Orderly malls were planted with long rows of Norway maples. The South Gate complex, with the administration building and public restrooms, the powerhouse, and the Reptile House, were the first structures completed.

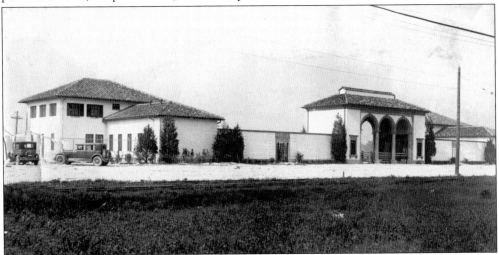

This 1928 photograph shows the South Gate and arcade, with the administrative building and "comfort station" (euphemism for restrooms) on the left. A headline at the time said, "Work on Chicago Zoological Gardens at Brookfield Progressing Rapidly." The following fall, however, all development and building came to a screeching halt with the stock market crash. No further construction took place until additional tax money and Civil Works Administration laborers became available in the 1930s.

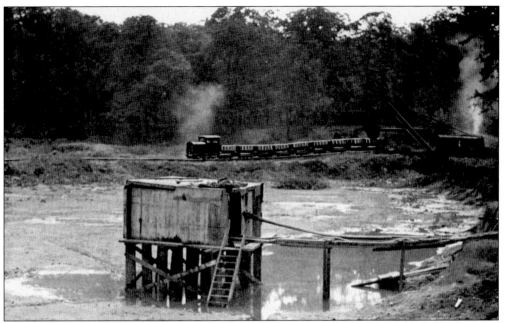

Indian Lake is seen under construction in 1927. Locomotive tracks were laid so a train could remove the tons of dirt and debris from the area. Indian Lake Trail is adjacent to the 10-acre Salt Creek Wilderness Preserve. Today one can stroll around this man-made body of water.

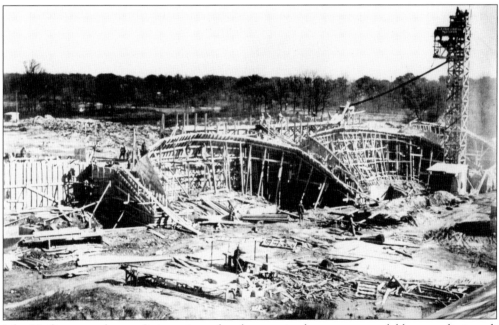

John Hurlimann, a famous Swiss artist and sculptor, arrived to create unscalable naturalistic rock formations and to construct the outdoor bear and large cat grottoes, as well as the "rock-covered" Pachyderm House. Animals would be viewed not in cramped cages, but in spacious landscaped settings surrounded by artificial rock backgrounds and moats. This would fulfill Edith Rockefeller McCormick's dream of a barless European-style zoo.

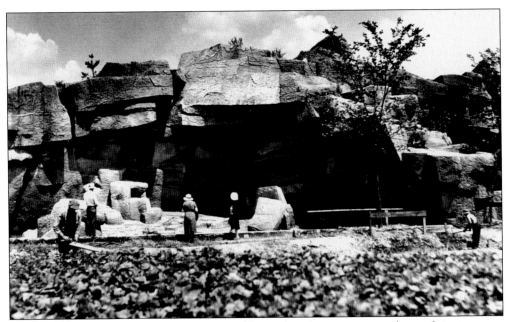

Early on during the construction, the zoo welcomed visitors to inspect the work in progress. This *Chicago Tribune* photograph from July 21, 1931, shows visitors inspecting the finished but still empty bear grottoes. Although the accompanying article indicated the entire park would be "ready-to-go within weeks," Brookfield Zoo would not open for three more years as a result of the Great Depression.

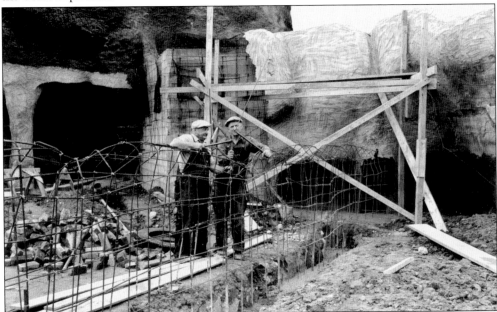

These two unidentified laborers are constructing rock work in the pachyderm yards in 1932. Note the steel reinforcing bar skeleton in the foreground that would be covered with metal lath. Next a thin coat of cement and sand plaster was applied to the lath with hand troweling. A great thickness of plaster was applied through a tube under pneumatic pressure. While this cement was still green—before the mixture crystallized—it was sculpted and tinted with fresco colors.

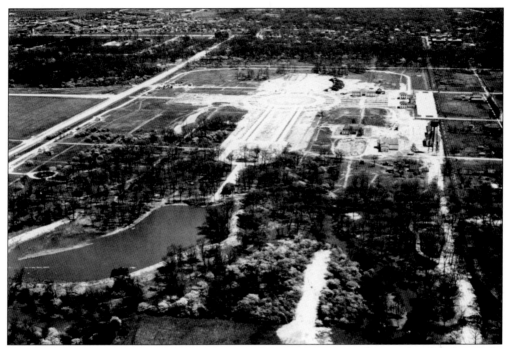

This 1929 aerial photograph looks east. Note the stunning, recently completed Indian Lake anchoring the western section of the park. One can see the beginnings of 216 acres of lovely wandering paths that continue to be enjoyed by guests today.

The two-year-old South Gate, dusty and forlorn in this *Chicago Tribune* newspaper photograph, is seen in 1929 just after the stock market crashed. Because of the Great Depression, it would be yet another five years before guests would be passing through this entrance.

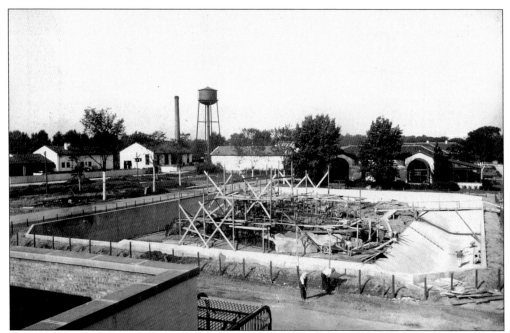

Construction of Monkey Island on the southwest side of the zoo would not be finished in time for opening day 1934. The exhibit would not be fully functional, with its many families of West African baboons in residence, until a year later. The water tower and standing furnace pipe that seem to dominate the background were removed in the 1980s.

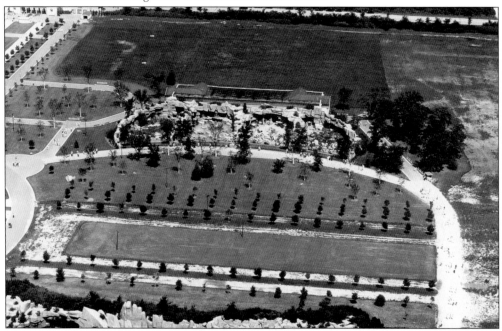

This very striking 1933 aerial view shows the completed eastern mall with the Lion House at the top of the photograph, and the Bear Grottos at the bottom. The rock work enclosing the lion and tiger yards was built to be a minimum of 16 feet high at its lowest point. The moat dividing the visitors and the animals was built to be 20 feet deep and 24 feet wide.

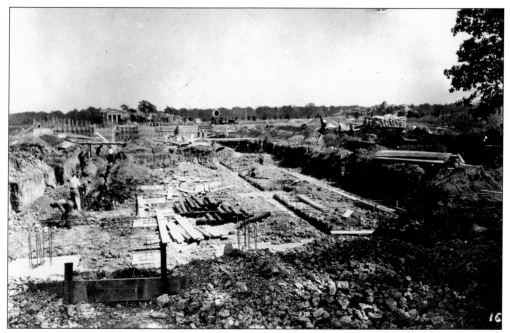

The construction of the Pachyderm House in 1932 was a massive, costly project. In the distance note the Corinthian columns of the finished Lion House, now the Fragile Kingdom. These initial buildings were erected before the park opened but only as tax income was received. No funds were ever borrowed.

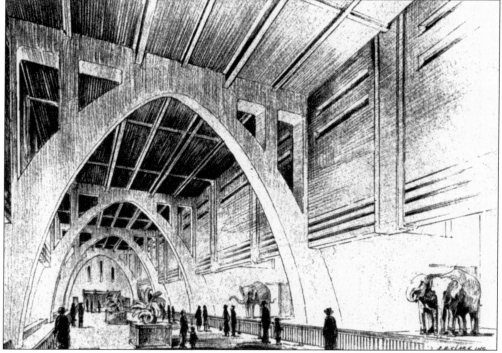

This architectural rendering by Edwin H. Clark shows the giant concrete ribs of the vast Pachyderm House. This was the largest building until Tropic World opened in the 1980s.

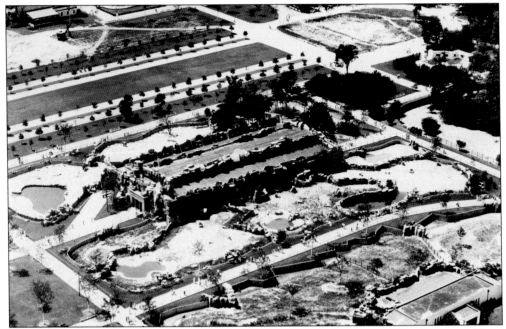

Entirely covered in rock work, from the ground the Pachyderm House (center) appears like a large hill or butte. The building, solidly constructed of metal, was designated as a community fallout shelter during the 1950s. The open area on the right side of the mall would soon be developed as Seal Island.

Seen here in the Pachyderm House are two of the hundreds of laborers and artists from the Civil Works Administration who constructed roads, walks, and exhibits, as well as the pedestrian tunnel underneath Thirty-first Street, adjacent to the North Gate.

Outside the Pachyderm House were the hippopotamus, rhinoceros, and tapir habitat yards with rock work, moats, and bathing pools. Note the sparseness of the scene—the landscaping was not yet in place.

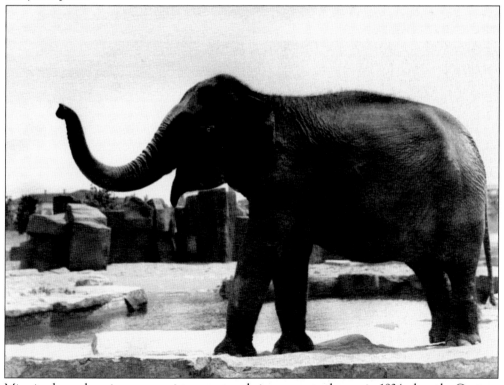

Minnie, shown here in a penny picture postcard view, came to the zoo in 1934 when the Century of Progress International Exposition closed. Until then, the four-year-old Indian elephant had been entertaining the crowds at the world's fair exposition.

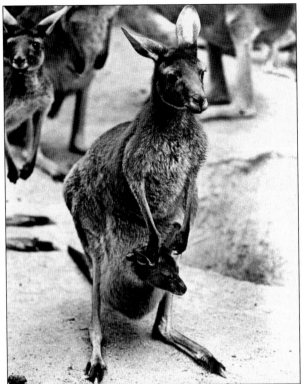

Animals began to arrive well before the opening of the zoo. The initial collection was composed of private donations, gifts from other zoos, and the purchase of specific animals to fill in the gaps from safari hunters. A western gray baby kangaroo, seen here protruding from its mother's pouch, is commonly called a joey whether male or female. Kangaroos are about the size of jellybeans at birth. Adult males use boxing behavior to determine mating rights.

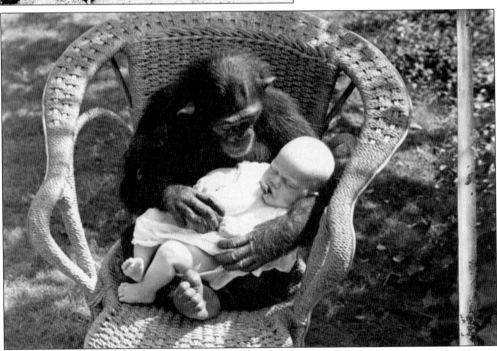

This gentle female chimpanzee's name was Meshie. Zookeeper Sam Parrott, who lived in a zoo-owned house on the grounds, routinely took monkeys and gorillas home to play and interact with his family. Meshie came from the French Cameroons in 1929.

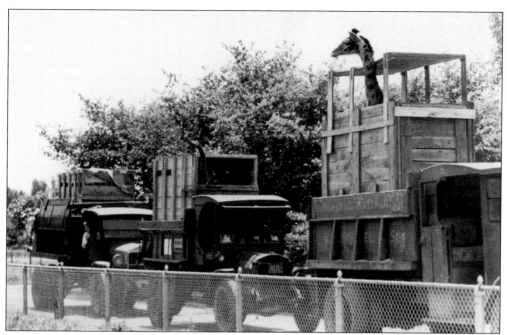

One particularly large gift of animals came from the George F. Getz private zoo—Lakewood Farms—in Holland, Michigan. The Getz collection, which provided much of the foundation of the early zoo, included 4 reptiles, 123 birds, and 143 mammals. Here is the first of the caravan of trucks arriving at Brookfield Zoo in November 1933.

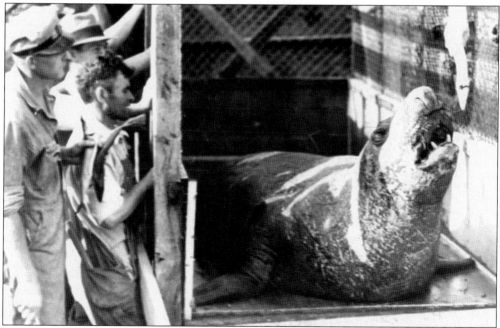

An elephant seal, part of the Getz collection, arrives at Brookfield Zoo. So named because of their large size and the older males' overhanging proboscis-like snouts, elephant seals were plentiful in the Pacific Ocean until late in the 19th century, when they were slaughtered wholesale for the oil that could be rendered from their blubber.

The regal Corinthian columns provide classical grace on the facade of the Lion House, finished in 1931 when tax money was again available. Today this structure houses the Fragile Kingdom.

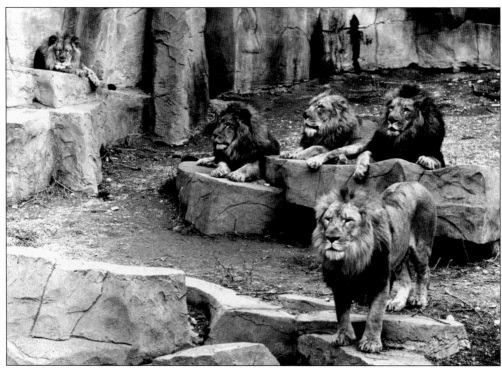

Animals were often exhibited in large groupings, which while highly entertaining for the guests who enjoyed watching them interact, often presented challenges in terms of care and expense. The male lion, who consumed up to 88 pounds of meat in one meal, could sleep up 20 hours a day. Reports from adjoining suburbs verified that the lion's roar could be heard up to six miles away.

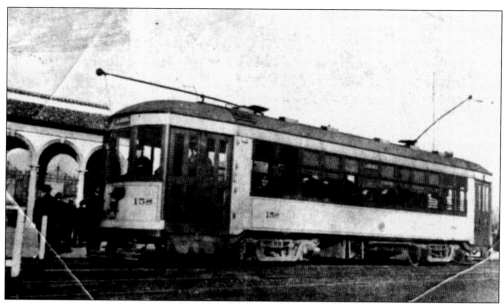

Many visitors to the zoo arrived via the West Towns Electric Railway. The railway's streetcars had wooden seats, clanging bells, and windows that were opened in the summer. The particular train seen here is about to arrive at the South Gate. The streetcar line lured people out of the city to enjoy Brookfield Zoo with 10¢ fares. This public transportation was discontinued in 1949 as more family car ownership increased during the postwar period.

On opening day, the park was dedicated early on June 30, 1934, before vast crowds arrived in record-breaking heat. The structure in the background, the Small Mammal House, now the Hamill Family Play Zoo, was not finished in time for opening day. The day was so hot, 13 women and 2 children were overcome by the intense heat and required medical care. A gang of pickpockets was operating in the crowded Pachyderm House until several gang members were arrested.

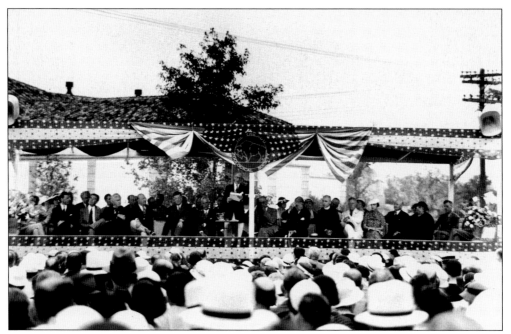

Chicago Zoological Society president John T. McCutcheon apologized that not everything was finished yet. "Someday, not too far ahead, we trust you will see the program rounded out," he told the growing multitude. "Not finished, of course, because we never expect to say our work is finished."

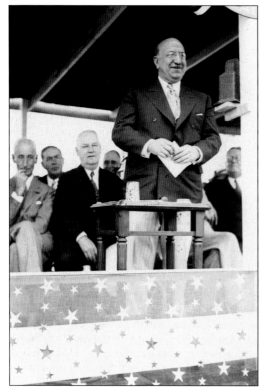

Many prominent people were present at the opening ceremonies. This speaker, Henry Horner (1878–1940), the first Jewish governor of Illinois and a lifelong bachelor, took a special train from Springfield for the occasion. Edith Rockefeller McCormick, the benefactress who provided much of the land for the zoo, had died two years earlier without seeing her vision for Chicago Zoological Park realized.

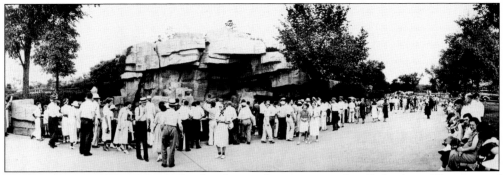

Hot but determined guests came by the thousands on opening day. Only about 75 percent of the planned exhibits were complete. Visitors had no chance to see the Small Mammal, Perching Bird, or Parrot Houses, or to watch baboons or seals on their islands. The tiny planted trees on the malls offered no shade. Still, the park was an unqualified success with the thousands who arrived at its two gates.

The Australia House was a classic in art deco architecture. Brookfield Zoo was the first zoo in the United States to feature animals from Down Under. Australia has the largest variety of marsupials of all the continents. With the reopening of the renovated Australia House during the early 1970s, the Chicago Zoological Society opened its first exhibit featuring animals in naturalistic settings, launching a nationwide trend.

Guests found the interiors of the zoo buildings as impressive as the outdoor exhibits and grottoes. This photograph was taken in the Aquatic Bird House, which sheltered water-loving birds. It is now titled Feathers and Scales.

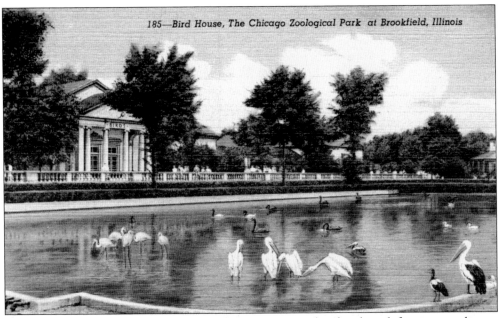

185—Bird House, The Chicago Zoological Park at Brookfield, Illinois

The Formal Pool, seen in this 1934 postcard image, was populated with pink flamingos, pelicans, and various geese and swans. The flamingos often stood on one leg for long periods, even when asleep, with the other leg tucked under the abdomen. This view, looking southwest, shows the Perching Bird House in the background. On opening day, July 1, 1934, 33,000 visitors were anticipated, but 58,000 people were actually admitted. Another 25,000 were turned away. The following Sunday, over 66,400 more guests visited Brookfield Zoo.

# *Two*

# SUCCESS STORY

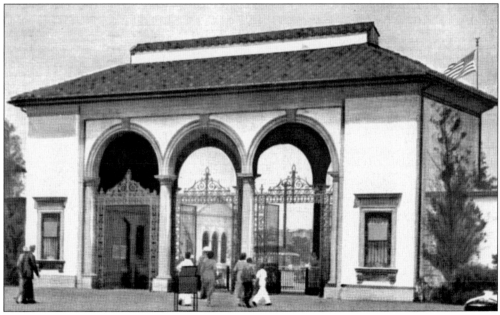

The elegant South Gate, with its ornate cast-iron gates, is featured on this postcard. Attendance figures for the period between opening day, July 1, through December 1934 had 1,292,720 guests walk through the gates of Brookfield Zoo. By 1938, attendance had grown to 2,089,223 a year. Despite the difficult economic times, the zoo was an unqualified success.

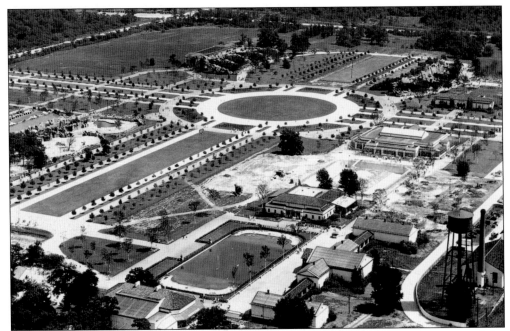

This 1934 aerial photograph from the southwest corner of the zoo shows the expanse of the Formal Pool, Perching Bird House, and Reptile House in the foreground. Note the large grassy circle in center of the park where the Roosevelt Fountain would be constructed 20 years later. In this photograph, one can see the first growth of the planted trees along the malls.

Zoo guests in their 1936 millinery finery are enjoying concession stand treats. The guidebook for that year stated, "Sandwiches, Coca-Cola, candy, and tobacco may be secured in a number of convenient situations within the park." A Baby Ruth candy bar or a Coke cost a nickel. Separate concessions sold items to feed the animals, such as marshmallows for bears and peanuts for monkeys.

This brightly colored West African mandrill, a short-tailed primate, was a highly popular Brookfield Zoo animal in the 1930s. The fluted cheeks were typically bright blue-violet with areas of scarlet in between the ridges. The mandrill's memory and intelligence are highly developed.

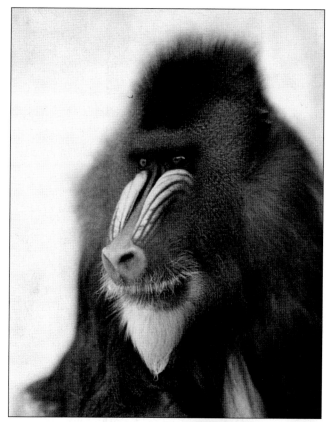

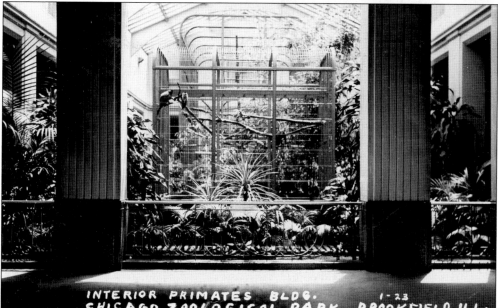

INTERIOR PRIMATES BLDG.    1-23
CHICAGO ZOOLOGICAL PARK    BROOKFIELD ILL.

This picture postcard view shows how the interior of the Primate House presented not only bold, beautiful design but lush vegetation and landscaping as well. Postmarked 1937, the message on back says, "There's an ape here who looks just like Uncle Louie."

In North American zoos during the 1930s and 1940s, the feeding of animals by the guests was standard practice. For one penny, a guest could purchase a handful of peanuts from a vending machine. Several truckloads of marshmallows were sold nearly every week. Later Brookfield Zoo would become the leader in zoological animal nutrition and such practices were discontinued.

A guidebook image from early spring 1941 documents the popularity of the Bear Grottos. During that period, the lion and bear enclosures were heavily populated with as many as seven or eight animals in one yard. The animals' nonstop interaction often brought cheers of applause and a shower of marshmallows from the crowd. In the wild, polar bears prefer seal meat. These bears arrived as cubs from the east coast of Greenland in the early summer of 1933. Note the formal attire, including hats, of the 1940s era.

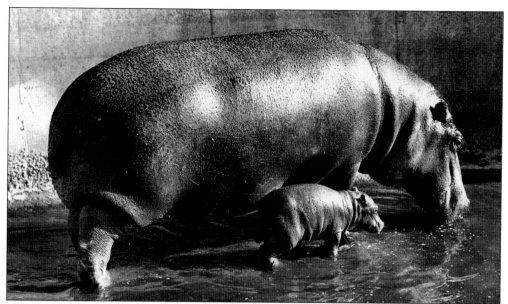

Puddle, a firstborn calf, is seen here with her mom, Bebe, a Nile hippopotamus. They became the stars of a hit 1936 children's book *Puddle: The Real Story of a Baby Hippo*. Puddle had received her name via a zoo-sponsored contest. The two runners-up in this name-the-hippo-calf competition were Hippotobias and Wimpy. Within five minutes of birth, young Nile hippopotamuses can swim and walk. In the wild, the mother allows her young to sit on her back while in the water. Bebe was two and a half years old when she arrived in October 1933.

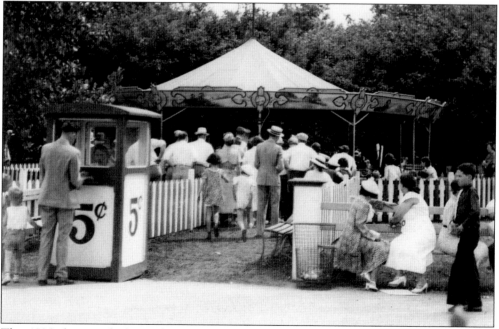

This 1936 photograph shows the zoo's merry-go-round in the woodsy northwest corner of the park near Thirty-first Street. Rides cost a nickel. After the Children's Zoo and Farm opened in 1953, and the liability insurance on the ride increased exorbitantly, the merry-go-round was dismantled.

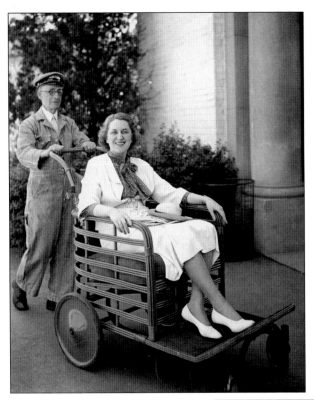

Brightly painted orange or blue wheeled chairs were available to guests to travel around the zoo. They rented for 50¢ an hour. An attendant to push cost 25¢ extra. The chairs were purchased from the Century of Progress International Exhibition when it closed in the fall of 1934. This smiling guest, with her hat in her lap, is enjoying a pleasant stroll past the Perching Bird House in 1938.

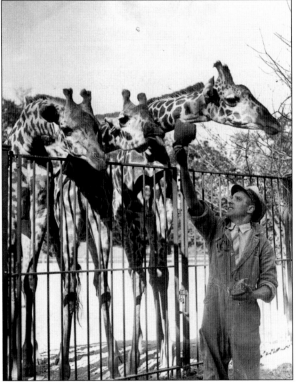

Here are three giraffes enjoying a snack. They are the tallest land animals and are born with horns—one of only a few species that are. While feeding, giraffes grasp leaves from branches with their 18-inch tongues as they twist their heads. Giraffes sleep only 30 minutes a day in 5-minute increments.

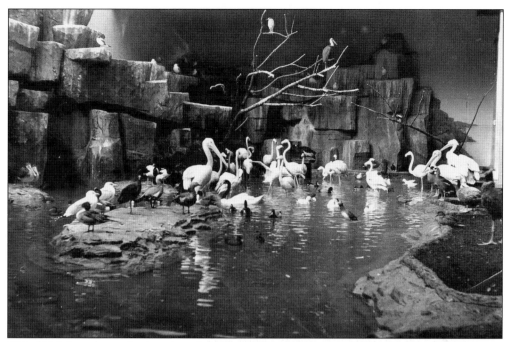

This 1936 shot shows the interior of the free-flight enclosure in the Aquatic Bird House, now Feathers and Scales. For decades, visitors could enjoy watching many water-loving birds such as storks, ducks, and flamingos.

This view shows several of the buildings surrounding the Formal Pool—the Reptile House (left) and the Perching Bird House (right). Admission was free three days a week, including the busiest days, Saturdays and Sundays. The Chicago Zoological Society never used public tax funds to pay for animal purchases during the early decades. It spent money raised through adult admissions, parking fees, the sale of refreshments, souvenirs, and guidebooks, wheeled chair and baby buggy rentals, and donations.

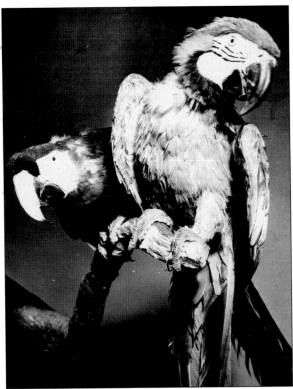

The beautiful plumage and intense interaction of the scarlet macaw and the blue and gold macaw could be seen in the Parrot House, which opened in 1935. Located on the west end of the Perching Bird House and adjacent to the Formal Pool, the Parrot House was converted into studio space for the Brookfield Zoo Design Department in the 1970s. Today guests can see the very large green-winged macaws in free flight at the Perching Bird House.

The Works Progress Administration (WPA) employed millions of Americans during the Great Depression. Busy WPA artisans work in their Brookfield Zoo studio designing signage, stone animal figures, fountains, and the large wooden directional markers. Free concerts by WPA bands were held in the grassy central circle (now the Roosevelt Fountain). Currently guests may view many of the zoo's restored WPA art pieces at the Discovery Center. The carved horned ram in the center can still be seen in the Safari Grill fountain.

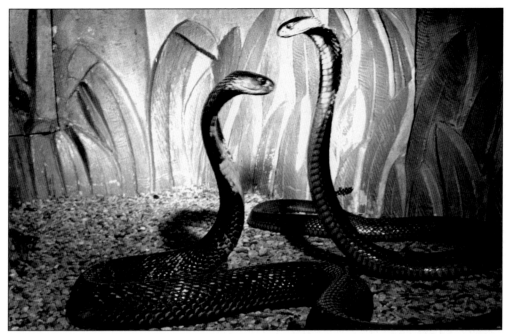

The decorative background scenery in the Reptile House was painted by WPA muralists. According to zoo guidebooks of the period, the Egyptian cobra, or asp, owed its principal claim to fame on the legend that the serpent was smuggled to the besieged Cleopatra as a means of suicide and escape from capture by the conquering Romans.

The Federal Art Project produced a popular series of posters for use on billboards, elevated trains, and streetcars throughout the Chicago area. This 1937 image depicts Su-Lin, an enormously popular panda.

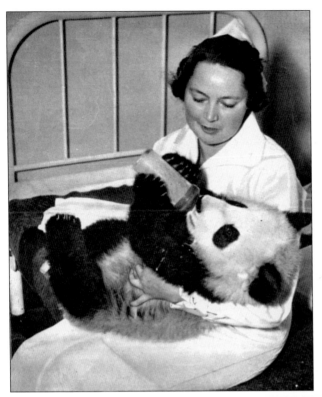

In 1937, through private collector Ruth Harkness, Brookfield Zoo acquired a giant panda from the remote Chinese mountain valleys of Szechuan Province. Su-Lin—Chinese for "a little bit of something precious"—was the first of the species to be displayed in the Western Hemisphere. "Panda-monium" resulted, with attendance rising to record numbers—more than 53,000 visitors in the first day. Mary Bean, zoo director Edward Bean's daughter, cared for Su-Lin. (Photograph by Teen Becksted.)

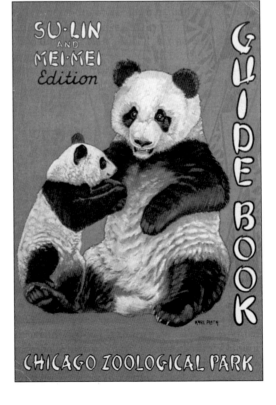

The first week's attendance was so great that proceeds more than repaid the cost of Su-Lin's purchase. Celebrities like Shirley Temple and First Lady Eleanor Roosevelt came to see the Brookfield Zoo panda. Soon another panda, Mei-Mei (pronounced may-mee), was purchased. This 1938 guidebook cover features a Karl Plath painting showing both Su-Lin and Mei-Mei. The latter's name meant "little sister." For a considerable length of time the animals were erroneously believed to be females.

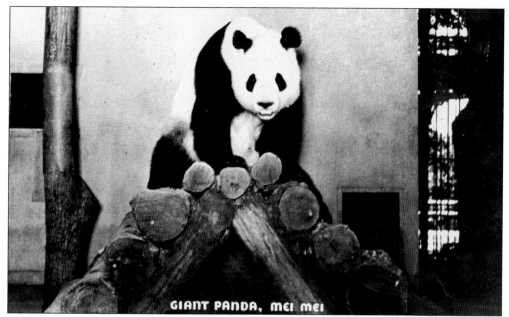

GIANT PANDA, MEI MEI

Overnight *panda* became a household word and toy pandas flooded the market. This 1937 postcard image shows Mei-Mei. Like Su-Lin, this giant panda was a male from Szechuan Province. Although their diet in the wild was believed to consist of bamboo sprouts, at Brookfield Zoo the pandas ate a variety of foods, including spinach, raw carrots, apples, whole wheat bread, milk, and porridge.

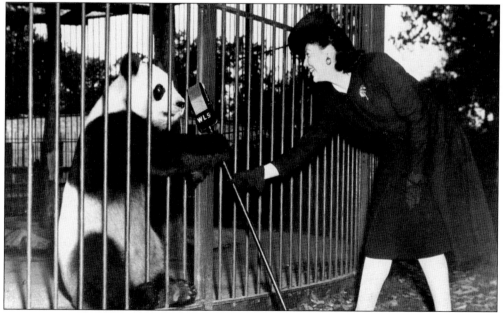

Mei-Lan, a third panda acquired in November 1938, routinely bit everyone within reach. Here the animal is being "interviewed" by Martha Gowdy on WLS Radio. The newspaper caption that ran with this photograph pointed out how the animal was "using her panda thumb to hold her microphone and send out a call to her admiring public." Reportedly, Mei-Lan ate the letters off this microphone.

Children loved to "make echoes" in the cavernous interior of the Pachyderm House. The six stalls for the elephants along the south walls could be opened and closed by remote mechanical control without the keepers exposing themselves to danger. The largest living land animals, elephants have eight-foot-long trunks containing 40,000 muscles and may spend 16 hours a day feeding. According to the national elephant census of 1940, Brookfield Zoo had eight elephants: Honey, Judy, Minnie, Nancy, Tembro, Ziggy, Zombie, and Zombini.

The North Gate, seen in a vintage picture postcard, faced Thirty-first Street. The large art deco–style gates were wide open to welcome guests in the early years of the zoo. Today those entering from the north end of the zoo walk through the underpass below the street. This gate is closed currently and the area houses an open marketplace for souvenirs and gift items.

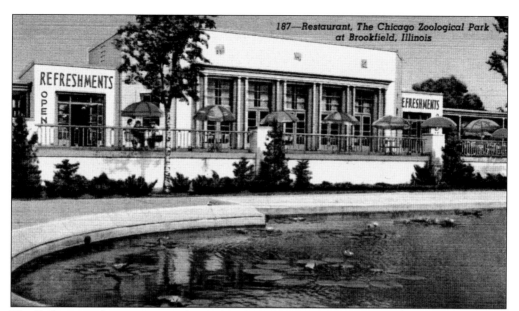

The Refectory, a large restaurant located at the terminus of the east mall near the Lion House, is seen here in a late-1930s postcard view. The architectural style, influenced by the European Bauhaus movement, included scores of specially designed outdoor tables and chairs on the sun terraces and under the loggias. A WPA sculpture including a ram, added to the goldfish pool in 1939, can still be enjoyed in its original location. In 1970, the Refectory was remodeled and renovated, becoming the popular new eatery called the Safari Grill.

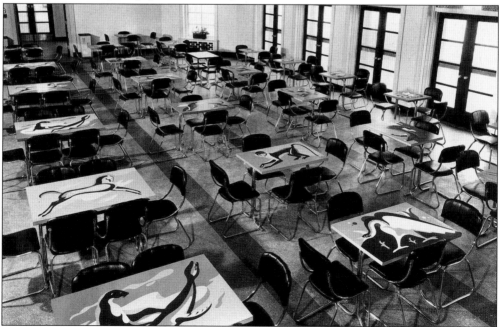

WPA artisan John Winters designed inlaid Formica animal tabletops in the Refectory, of which 20 are on display in the Discovery Center. The state-of-the-art chrome chairs, influenced by Marcel Breuer's classic minimalist furniture designs, combined bent tubular steel with washable, plastic-coated canvas.

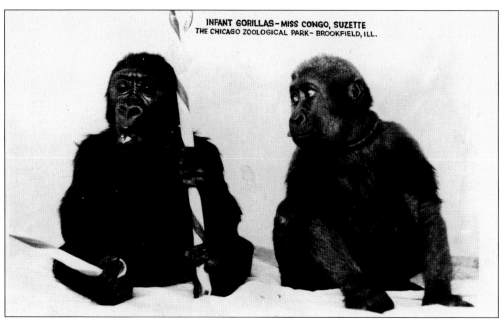

INFANT GORILLAS - MISS CONGO, SUZETTE
THE CHICAGO ZOOLOGICAL PARK - BROOKFIELD, ILL.

Miss Congo and Suzette were two female gorillas "rescued," as the caption on the back of this postcard states, from the Belgian Congo in June 1936. Although they reportedly did not get along well with each other, these beloved female gorillas were featured together on a series of picture postcards. In the 1930s, Hollywood both popularized gorillas and perpetuated many myths through the *Tarzan* series and the film *King Kong*.

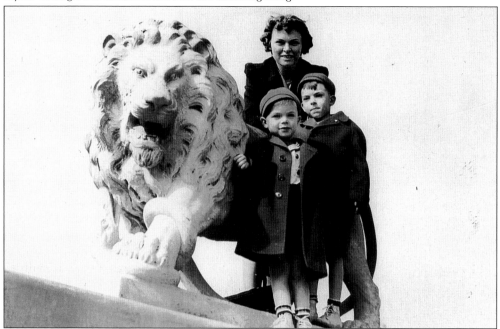

A zoo guest, Alice Lundstrom, is seen here with her sons John and Carl, posing by one of the zoo's cement lions in 1940. The sculptures, once part of a private estate in Oconomowac, Wisconsin, were given to the zoo in its early years. Alice, born in 1906, is an active gardener at 103 years of age.

This ostrich, one of a pair, drew lots of attention from visitors because it stood nearly eight feet tall located near the antelope paddocks. These giants are the largest living birds in the world. The flightless nomads, native to Africa, have long legs and can run at speeds up to 46 miles per hour—the top land speed of any bird. They run, not fly, to escape predators. In the early 20th century, they were heavily hunted for their feathers, widely used in millinery in that period. Guests can see Abby the ostrich holding court in the warthog yard of the Habitat Africa! exhibit.

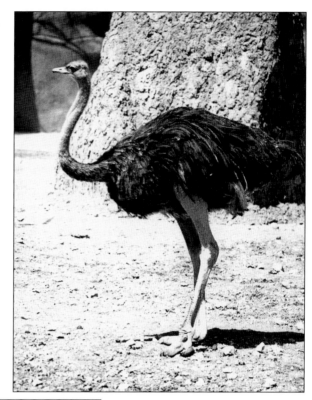

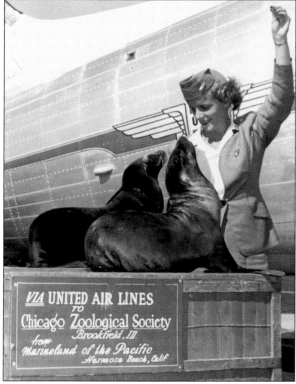

These elephant seals are especially interested in what this unidentified United Airlines stewardess might be offering them during a break en route from New Zealand to Brookfield Zoo in March 1938. During the early decades, the majority of animals in the zoo were transported to their new home from remote regions all around the world.

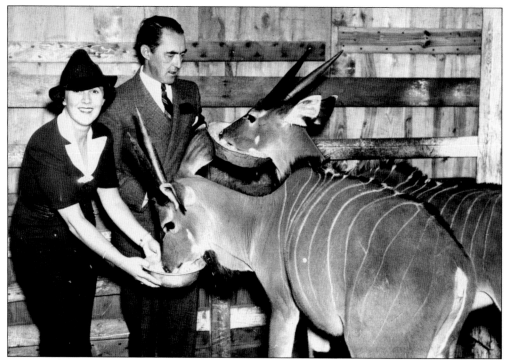

Robert Bean and WLS Radio personality Martha Gowdy are feeding two adolescent giant eland in the Small Antelope House around 1939. Eland, depicted in early rock work paintings, are swift-running, grazing animals from the open plains of southern Africa. Both sexes have horns that spiral as they mature. Today guests can view the aardvarks there. Bean, then curator of mammals, served as director of the Chicago Zoological Park from 1947 to 1964.

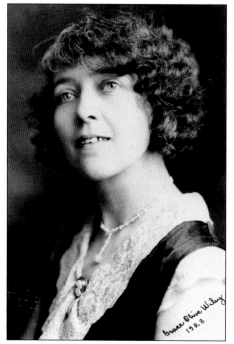

Grace Olive Wiley, Brookfield Zoo's first curator of reptiles, was an eccentric but purposeful woman working in a male-dominated field. Hired in 1933 at $1,800 per year, Wiley was the first person to successfully breed western diamondback rattlesnakes in captivity. "When I'm bitten," Wiley would say, "I blame myself, not the snake." After her dismissal from Brookfield Zoo for repeated "negligence with dangerous reptiles," Wiley succumbed to a cobra bite in 1948.

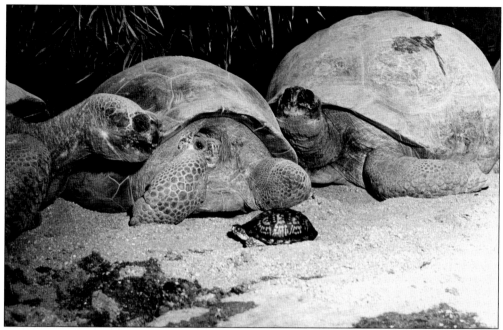

Seen in the Reptile House in 1938 are Galapagos Island tortoises. Found off the west coast of Ecuador, the tortoises can live as long as 150 years of age. Children enjoyed peeking over the balustrade to see these large graceful creatures. The small North American box turtle in the foreground ate fruit, berries, earthworms, and ground beef.

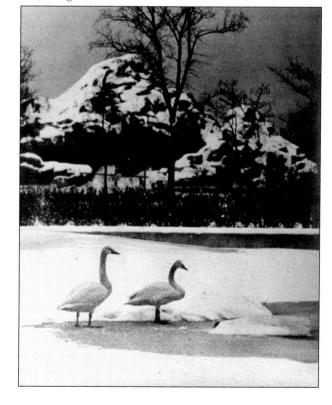

Seal Island, a mountainlike cement structure surrounded by a water-filled moat, is seen in the background in this 1937 winter scene. In the foreground are whooping swans, noted for vocalizing with a deep honking call. Later this cement structure, surrounded by a moat filled with water, was renamed Ibex Mountain.

Ralph Graham, a WPA artist and Federal Art Project supervisor, provided vivid pen-and-ink illustrations for the annual 25¢ Brookfield Zoo guidebooks, as well as many murals, exhibit backgrounds, and maps. He also wrote the text and painted the artwork on zoo signage. After Graham's service in World War II, he returned and was hired as the official zoo photographer in 1945.

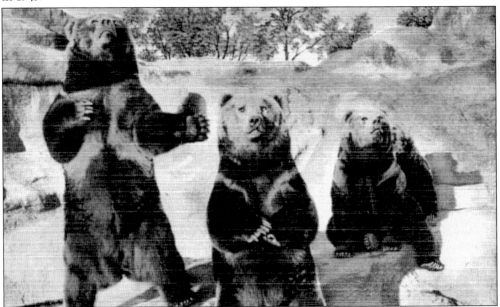

This picture postcard shows three Kodiak bears that arrived from Kodiak Bear Island to the zoo at seven months old in 1933, a year before the zoo opened to the public. Brookfield Zoo was the first zoo to have Kodiak bears to reproduce. These vividly tinted postcards were widely purchased by enthusiastic visitors who mailed them to their friends and families, urging them to come see the wonders of the new zoo.

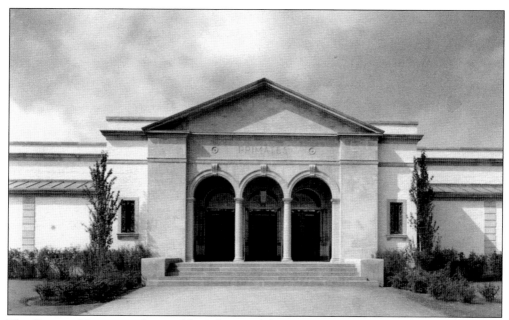

The Primate House was designed by Edwin H. Clark in the classic Renaissance Italian style. Around the western outer walls were 32 enclosures that could be used about seven months of the year. During the 1980s, the apes and monkeys moved into Tropic World. Although renovated and redesigned as the Swamp in the mid-1990s, the current look of the building incorporates many of its original architectural features.

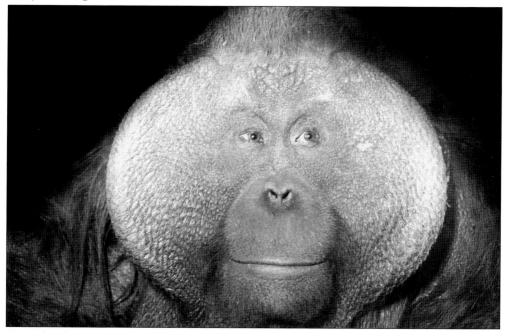

Tia, a female orangutan who arrived from the lowland rainforest of Borneo in 1934, was about 12 years old. Scarcer and less social than the gorillas or chimpanzees, orangutans were more challenging to maintain in captivity. But Tia developed a wide following of fans that came to the zoo frequently just to visit her. Guests can experience orangutans in Tropic World.

The Bear Grottos, seen here in a 1937 postcard image, were often cited by guests as their favorite outdoor exhibit. At the time, the state-of-the-art environment attested to Brookfield Zoo's great care and attention to naturalistic details. Attendance at the zoo continued to climb during the period, despite the hard times of the Depression years.

Behind the scenes, near the South Gate, was a group of service buildings, including a carpentry shop, a paint shop, a greenhouse, a garage and stable, the animal food warehouse or commissary, and a coal-fired powerhouse. Food for the animals was prepared in bulk in the commissary kitchen.

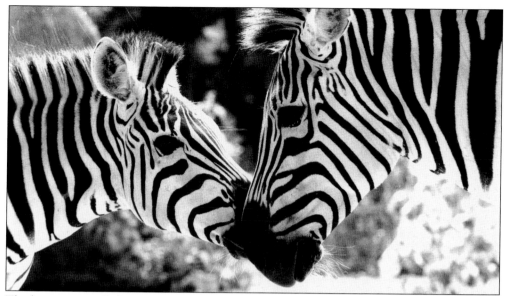

The largest type of zebra at Brookfield Zoo is the Grevy's zebra, with its white belly. The stripe pattern is unique to each animal, much like fingerprints. The ancient Romans called zebras "horse tigers" when they brought them back to Rome to exhibit them in circuses. The zoo has successfully bred zebras since 1937.

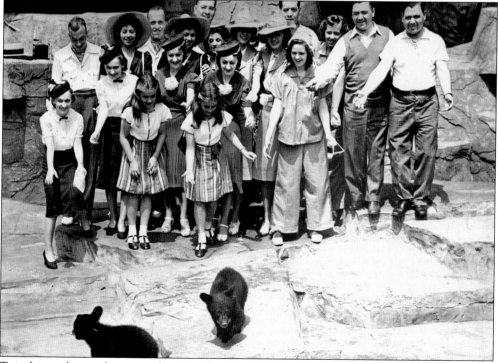

Twin brown bear cubs inspired a zoowide Twin Day celebration in 1940 that involved a picnic and a variety of photo opportunities. The zoo held frequent special events featuring visiting celebrities, big bands, radio personalities, actors and actresses, and a variety of contests and festivities. The events were widely publicized throughout Chicagoland.

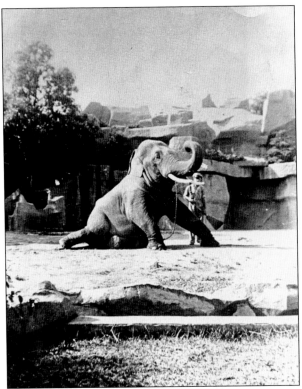

Perhaps the most famous resident of Brookfield Zoo was Ziggy (short for Ziegfeld, the early-20th-century showman who was the elephant's original owner). Ziggy, in fact, had been kicked out of the Ziegfeld Follies for being rambunctious. The 16-year-old bull arrived at the zoo in 1936. By the 1950s, Ziggy was believed to be the largest animal in captivity in the United States.

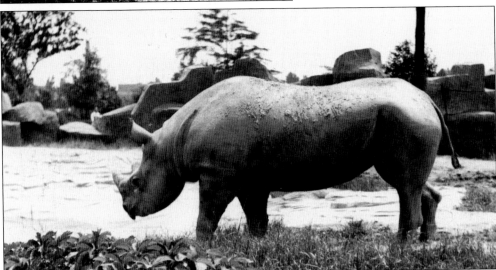

This is Korongo, a male African black rhinoceros born near Mount Essiminger near Lake Manjara, Tanganyika, in January 1931. Although rhinoceroses are considered aggressive, they are usually timid. Today they are critically endangered because their horns are believed by some to have magical, medical, or even aphrodisiac qualities. The Chicago Zoological Society currently supports preservation efforts of the International Rhino Foundation. The term *pachyderm*, incidentally, refers to the thick skin possessed by rhinoceroses, elephants, hippopotamuses, and tapirs, which are housed adjacent to one another in the zoo. None of these groups is actually closely related.

From the beginning, the Chicago Zoological Society was recognized for its many "firsts." This photograph from the 1938 guidebook shows a pair of addax, the first to be exhibited in this country. One of the most endangered mammals in the world, addaxes once populated the entire Sahara Desert in Tunisia and Algeria. They are easily recognized by their spiral horns. Their broad hooves are adapted for running over loose sand. Like other desert antelopes, these unusual-looking creatures can go for long periods without water.

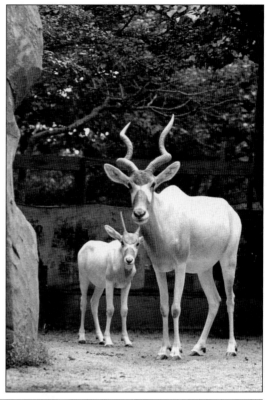

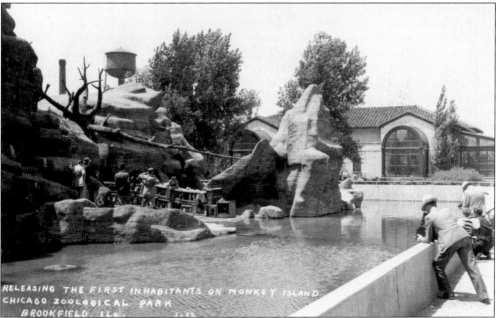

RELEASING THE FIRST INHABITANTS ON MONKEY ISLAND
CHICAGO ZOOLOGICAL PARK
BROOKFIELD ILL.

Monkey Island, more recently known as Baboon Island, was finished in 1936. The large moat was kept filled with fresh water. In 1948, when an eight-year-old boy climbed over the guardrail and fell into the 10-foot-deep water, an off-duty policeman jumped in and rescued the child. From then on, the moat has been kept empty.

These guests are enjoying a stroll along walks in front of the Refectory near the Lion House on a warm summer day at the zoo in August 1947. The wide-open spaces the zoo provided were much appreciated by postwar guests.

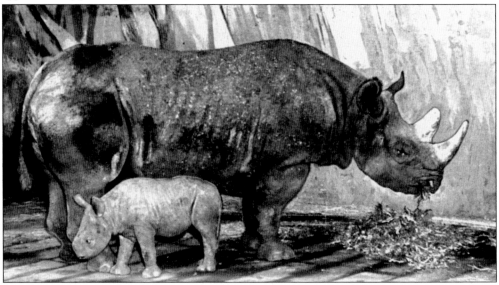

Brookfield Zoo was the first zoo in North America to successfully breed African black rhinoceroses in captivity—as well as several other species. A black rhinoceros calf named Georgie-Joe, weighing 50 pounds, was born to eight-year-old Mary on October 7, 1941. Although actually more copper colored than black, these rhinoceroses usually are covered with a dried gray mud coat that protects them from sunburn, skin parasites, and insect bites. Black rhinoceroses are extremely nearsighted but have a very keen sense of smell and excellent hearing. They are currently perilously low in numbers in the wild due to illegal hunting.

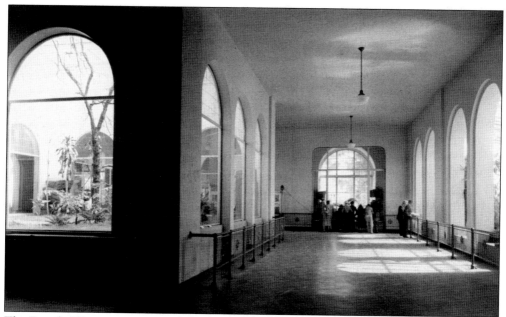

The Reptile House interior is seen here in 1944 when the World War II years were especially challenging for Brookfield Zoo. Shortages and rationing were ongoing problems. Attendance dropped drastically during wartime. The Small Mammal House was closed for the duration. Many zoo workers went into military service or found more lucrative employment in defense plants. The collection was reduced to a minimum, with duplicate animals sold or given away.

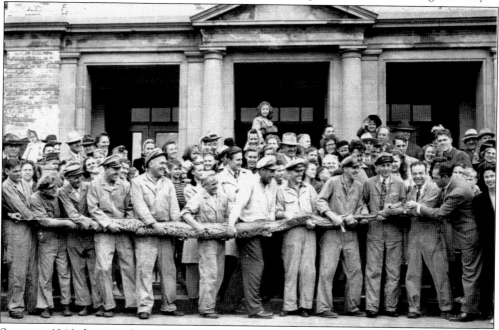

Seen in a 1946 photograph, zoo director Robert Bean (right, holding the tape measure) recruited 11 zoo employees to help him unfurl the newly arrived giant anaconda called El Diablo. The 13-foot, 9-inch Colombian constrictor, which cost $450, was later renamed La Diabla after a litter of anacondas was discovered. The anaconda is the world's heaviest snake.

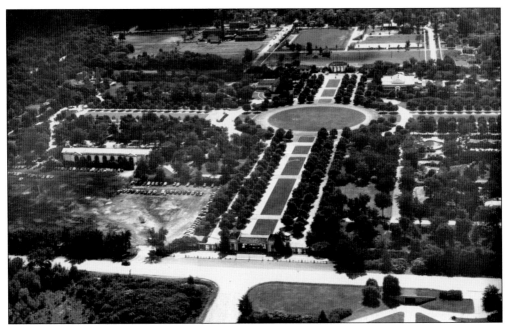

This 1948 aerial view looks south toward the North Gate in the foreground. The underpass beneath Thirty-first Street, completed by WPA workers a decade earlier, can be seen in the lower right, just south of the parking lot. The Lion House, now Fragile Kingdom, is on the left. The Roosevelt Fountain would not be constructed in the center circle for another six years.

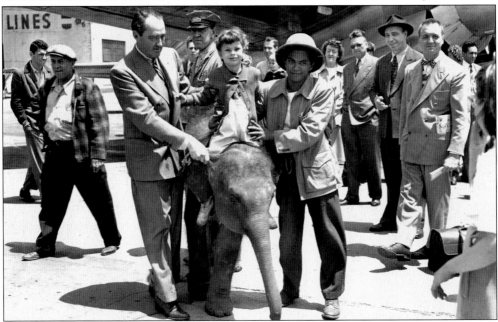

Adrian Fukal is pictured here in 1947, riding a baby elephant that had just flown from Siam to Chicago. Fukal is the mother of current Chicago Zoological Society Information Services employee Jennifer Smith. Flanking the year-old animal at Midway Airport are zoo director Robert Bean (left) and naturalist John Royola (right), who accompanied the elephant on the flight from Asia.

# *Three*

# MIDCENTURY MATURITY

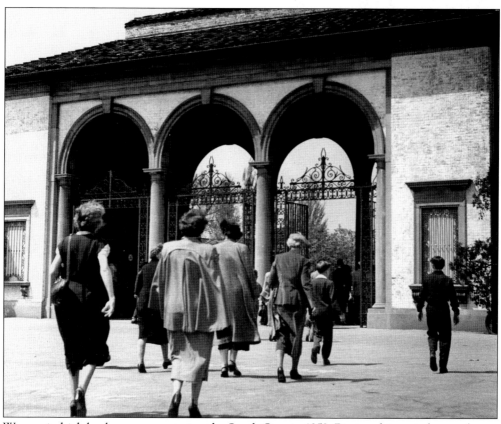

Women in high heels are seen entering the South Gate in 1952. During this period not only was attendance increasing, but many new changes were in the works for Brookfield Zoo. It would become an exciting period in the development and growth of the Chicago Zoological Society, with notable advancements involving in-depth research, affiliations with universities, and an increasing focus on conservation.

Seen here in 1953, the Refectory restaurant, at the centrally located end of the eastern mall, had large geographic murals by Ralph Graham, showing many hundreds of zoo animals in their natural homelands. Unfortunately, when the building was renovated and retooled in the early 1970s as the Safari Grill, the murals were not salvageable.

Guests were often captivated when they observed animals at feeding time. These young visitors are watching the penguins in the Aquatic Bird House in 1950. Zoo admission continued to be free Thursdays, Saturdays, and Sundays—and 25¢ the other days. Children under 15 were always admitted free.

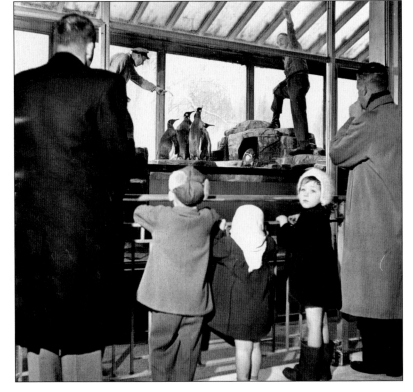

Reggie, a northern elephant seal, consumed about 100 pounds of mackerel daily. Delighted children and their parents eagerly watch feeding time at Seal Island in 1955. For many years, only men worked in the field as zookeepers. The moat and Seal Island, later called Ibex Mountain, would be removed in 2008 to make way for the Great Bear Wilderness exhibit, set to open in 2010.

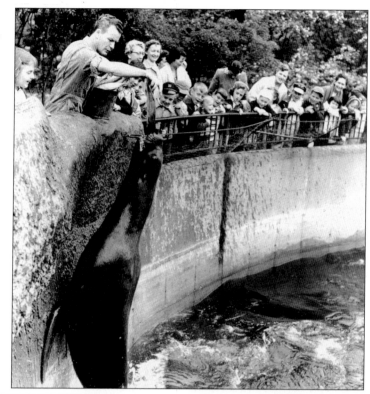

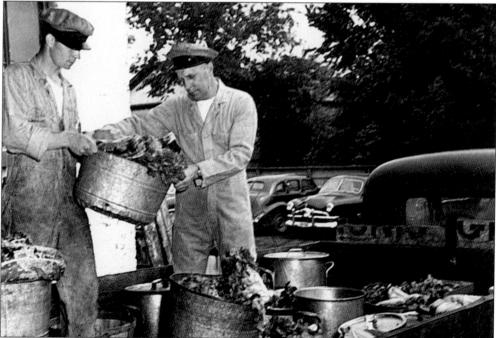

Brookfield Zoo became well known for its comprehensive animal nutrition program. Zookeepers Slim Lewis (left) and Frank Snyder are working with zoo-grown produce at the commissary in 1950.

During migration time each year from late August to late October, bird-watchers, or birders, made regular pilgrimages to picturesque Indian Lake, tucked away on the zoo's west side. Those who were observant and patient often located many birds. In the fall, many species continue to migrate through the area, including hawks, herons, woodpeckers, swallows, wrens, and orioles.

Seen here in 1951, the Aquatic Bird House (now Feathers and Scales) cost $112,000 when it was first constructed. When it opened in 1934, the *Chicago Tribune* called it "the most beautiful building for its purpose in America." A large stainless steel open-flight area allowed birds to fly in an outdoor setting containing three small oak trees. Now two Andean condors, Jesus and Maria, inhabit the enclosure on the west side of the building.

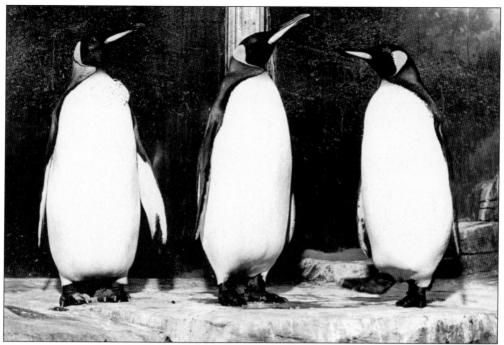

King penguins inside the Aquatic Bird House on the north end enjoyed a large air-conditioned, glass-fronted tank that allowed them to show off their swimming skills. Most penguins live on a diet of smelts or sardines, but king penguins prefer baby mackerel.

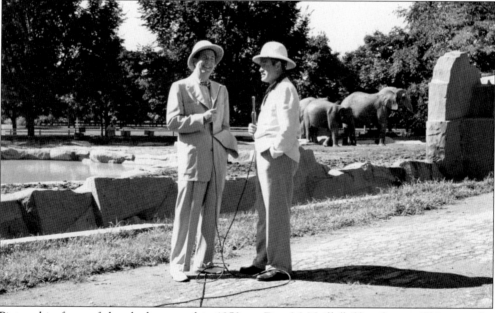

Pictured in front of the elephant yard in 1950 are Don McNeill (left), a famous Chicago radio personality whose daily program was called *Don McNeill's Breakfast Club*, and movie star and comedian Bob Hope. The pair did a live broadcast while strolling on the zoo grounds. During the 1950s and 1960s, the growing importance of broadcast media allowed the public to keep plugged in to zoos all across the nation.

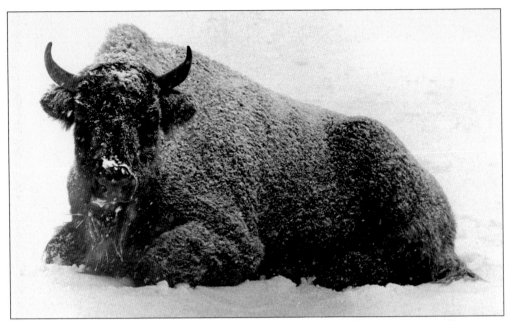

People often refer to bison as buffalo. This North American bison, despite its huge bulk, can run at speeds of up to 37 miles per hour. In the early 19th century, there were vast herds of bison, numbering from 40 to 60 million, but widespread hunting reduced their numbers down to about 500 by 1886. Guests will be able to experience Brookfield Zoo bison in a new setting in 2010 with the opening of the Great Bear Wilderness.

As early as 1928, the bison was featured on the cover of the first annual report of the Chicago Zoological Society, reflecting the organization's early engagement in bison conservation. They are now recovering their numbers. The bison conservation logo is featured on this 1946 zoo vehicle, and a contemporary version of the logo continues to be seen throughout the park today.

A favorite among children but now forgotten, the Illinois Exhibit sat in a sunken, open-air grotto in the zoo's west end. Freestanding viewing units featured mammals native to the state, such as coyote, squirrel, red fox, woodchuck, and opossum. Large frescoes painted by WPA artists had been inspired by original pictographic records of area Native Americans. By the mid-1960s, however, this patio structure had become so run-down that it was finally demolished.

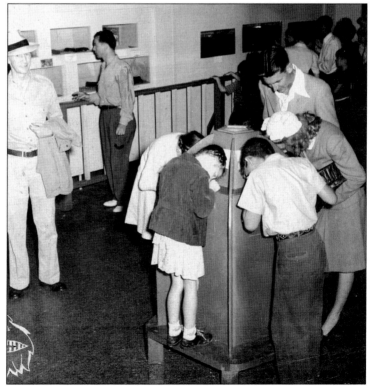

In 1947, a special demonstration zone was installed in the east end of the Bird Terrace. A popular attraction, located in what is now Woof-Field Gifts, was a fascinating show called "Animals without Backbones." Large movable lenses gave a close-up view of insects and other smaller invertebrates. In the archway, at the rear of the building (now the library), was a microprojector that enlarged bugs to giant size.

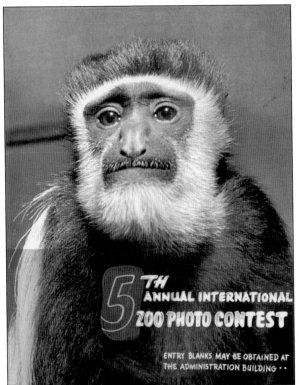

The Brookfield Zoo International Annual Photograph Contest was started in 1947, and amateur and professional photographers continue to enter from around the world to this day. This wise-looking Uele colobus monkey was used as the poster advertisement for the contest in 1951. The species is the most arboreal of all African monkeys, rarely descending to the ground despite not having thumbs. These primates are endangered by the forest fragmentation problems across Africa.

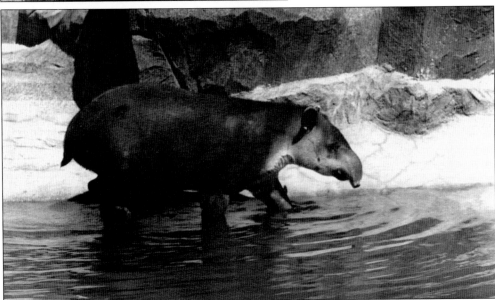

Tapirs have not changed much in 35 million years. This six-month-old female Central American tapir calf arrived in 1934 from a dense Honduran forest and lived at Brookfield Zoo for over 20 years. Docile and surprisingly agile on land, she weighed 700 pounds. Today endangered tapir populations are declining due to hunting and the destruction of their habitat. The Chicago Zoological Society has an active role in tapir conservation. Guests can see a tapir at Pachyderm House or Tropic World.

This July 1953 photograph shows crowds of summer visitors at the Refectory eatery. Many visitors pitched coins for good luck wishes into the goldfish pond. During the baby boom years, sunny summer days at the zoo brought delight to thousands of families.

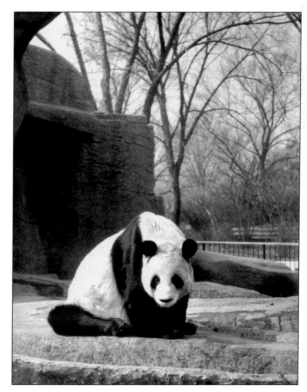

Mei-Lan, meaning "little flower," arrived at the zoo in November 1938 as a one-year-old and lived in a specially created panda pad. Mei-Lan died in September 1953.

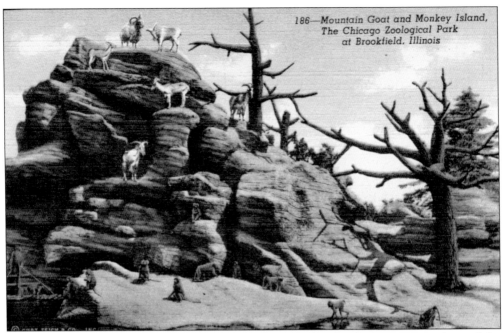

186—Mountain Goat and Monkey Island,
The Chicago Zoological Park
at Brookfield, Illinois

This picture postcard view of Monkey Island, postmarked 1951, shows some members of the collection of Dall sheep and the scores of West African baboons whose activities fascinated zoo visitors for many decades. Interior shelters concealed under the rock work were electrically heated and ventilated.

According to the 1953 guidebook, the most frequently asked question in the Reptile House was "How do you tell the difference between an alligator and a crocodile?" The American alligator has a wider snout than the crocodile. Alligators also have U-shaped heads while crocodiles' are V-shaped. An alligator's average weight would be in the 800-pound range. Of the large number of alligators in the swamp seen here on the south side of the Reptile House, all but one was a gift. Baby alligators were often given to children as pets in that era; they would end up at the zoo once they began to grow larger.

This striking photograph of several highly venomous East African green mamba snakes was reprinted for several years in the annual 25¢ zoo guidebook. Greatly feared, these fast-moving tree dwellers from Kenya have a potent poison. Guests were drawn to the Reptile House to see the large variety of reptiles and amphibians.

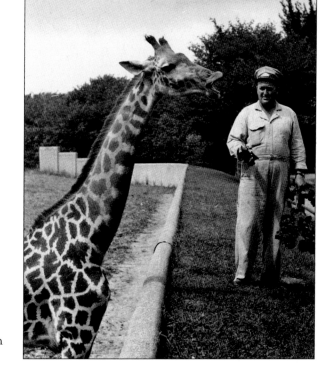

Ready for lunch, one of the reticulated giraffes is anxious to be fed by William Huizinga, the head keeper, in 1951. Recently it has been determined that giraffes, rhinoceroses, and elephants make infrasounds, a type of communication not heard by humans. In 1993, the Habitat Africa! exhibit opened, providing the giraffes a naturalistic setting in which to roam.

The Question House, located just south of the Formal Pool, first opened in 1947. Alexander Lindsay, running a one-man operation, answered questions about the park, animals, and specific zoo exhibits. Lindsay opened for business every weekend and holiday.

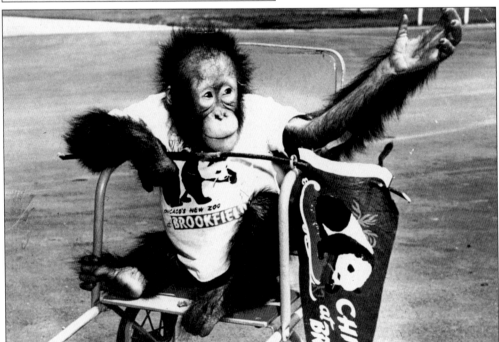

By the early 1950s, the zoo offered visitors a variety of caps, toys, pennants, and other popular souvenir items, several of which (note the T-shirt and pennant) are being shown off by one of the young chimpanzees in a publicity photograph.

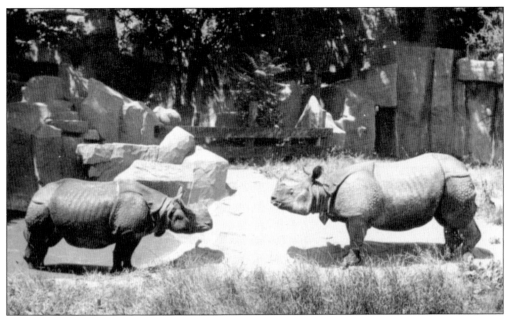

Kashi Ram (male) and Kamala Rani (female) were two remarkable rhinoceroses brought from India to Brookfield Zoo in 1948. Indian rhinoceroses are grazing animals that inhabit swampy grasslands.

The groundbreaking, state-of-the-art Animal Hospital, completed in 1952, cost $260,000. Funds were obtained over time through 3¢-per-bag profit derived from the sale of 8,633,334 bags of peanuts. The one-story building, located just south of Monkey Island, contained both diagnostic and research facilities, including laboratories and a surgical room. In 1995, the structure was renovated and became the Daniel F. and Ada L. Rice Conservation Biology and Research Center. Today scientists develop groundbreaking work in animal welfare, endocrinology, population biology, conservation psychology, and guest survey research.

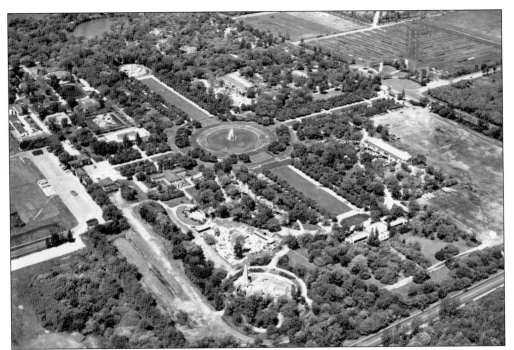

This 1954 aerial view of Brookfield Zoo shows the recently completed Roosevelt Fountain "geysers" in the center circle of the park grid. During the next several years, the Children's Zoo and Farm would expand into the circular Kodiak Bear Island (lower left).

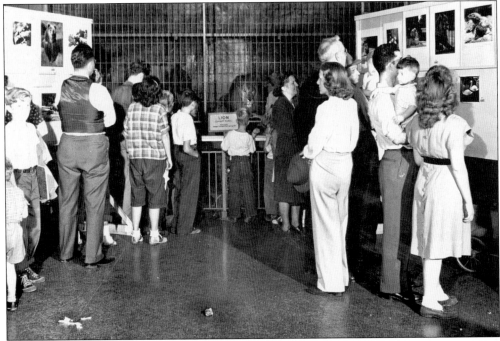

Visitors are eagerly seeking out their favorite images at the 1955 Annual International Zoo Photography Contest here in the Lion House. Prizes were awarded, and the best entries were often featured in the upcoming guidebook.

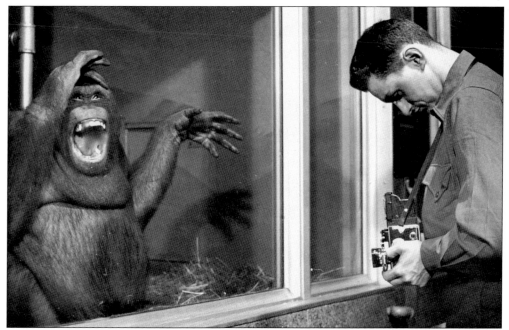

Seen here in an uninhibited moment, this orangutan reacts in response to the cameraman in the refurbished Primate House in the 1950s. This photograph, an entry in the zoo's annual photography contest, shows the special glass that was devised and used instead of heavy iron bars.

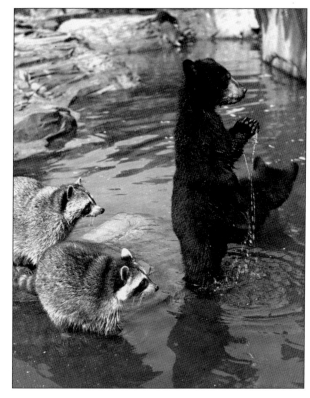

This *c.* 1956 image, taken by Ralph Graham, shows lounging raccoons native to northern Illinois that frequently visited the grotto inhabited by the black bear cubs.

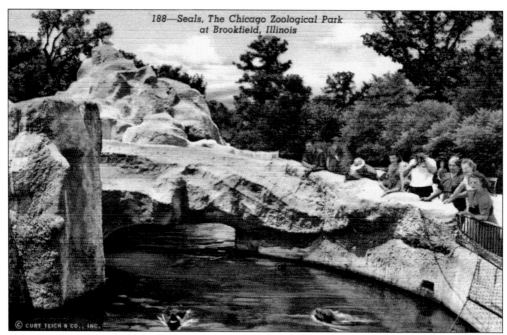

188—Seals, The Chicago Zoological Park
at Brookfield, Illinois

Seal Island drew large numbers of excited guests throughout the 1950s. This postcard view shows the bridge that allowed visitors to cross the moat into an interior snack shop, the Igloo, where ice-cold treats like snow cones and Eskimo pies were served. Later called Ibex Mountain, this exhibit was removed in 2008 to make way for Great Bear Wilderness.

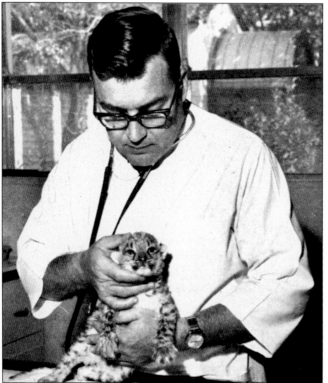

As a leader in veterinary medicine, the Chicago Zoological Society was the third U.S. zoo to establish an animal hospital with their grand opening in 1952 and to employ a full-time veterinarian. Dr. Joel Wallach is seen here vaccinating a snow leopard. Preventive medicine was always a hallmark of the zoo's approach to veterinary care. All the animals were routinely inoculated against diseases. Surgery was conducted in the zoo's new animal hospital.

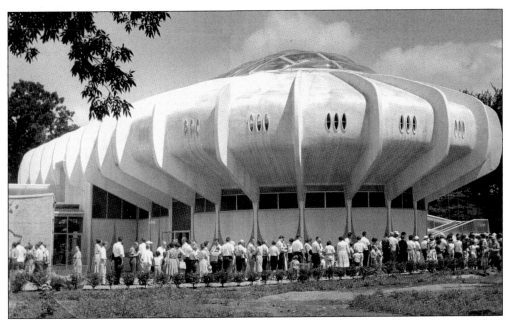

The dolphinarium, a zany spaceshiplike superstructure, opened in the southwest corner of the park in 1961 where the Living Coast now stands. Looking like a flying saucer, the enormously successful Seven Seas Panorama provided the first opportunity to see marine dolphins inland. The pool was 100 feet long, 25 feet wide, and 16 feet deep at its greatest depth. After two and a half decades of deterioration from salt water and constant heavy usage, the attraction was rebuilt and expanded on the eastern side of the zoo in 1987.

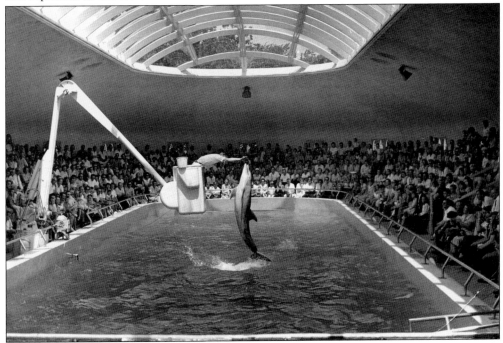

This 1965 postcard image shows a dolphin flying through the air, in response to a command, in front of a packed house at the big tank at the Seven Seas Panorama.

73

The busy North Gate welcomed guests off Thirty-first Street. Attendance continued to rise during the postwar period. "Going to the zoo" became a frequent family outing, attracting a diverse population. Zoo attendance was up to 2.015 million in 1961, due to the opening of the immediately popular Seven Seas Panorama.

In the Freedom Gallery in the 1950s, guests now could walk into a wide-open expanse in the Perching Bird House. A tropical forest exhibit was created for $125,000 where birds could fly freely. It accommodated over 50 different species.

The 1960s brought innovations in zoo transportation. In 1962, over 12,500 linear feet of 30-pound rail was installed for a narrow-gauge, steam-powered railroad, expected to transport half a million passengers a year around the periphery of the zoo. This crew is laying railroad track behind the Perching Bird House.

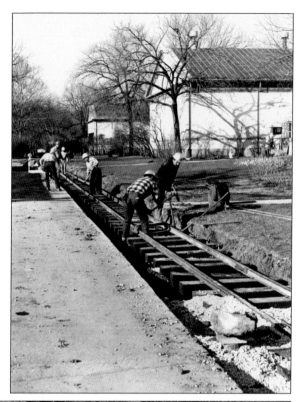

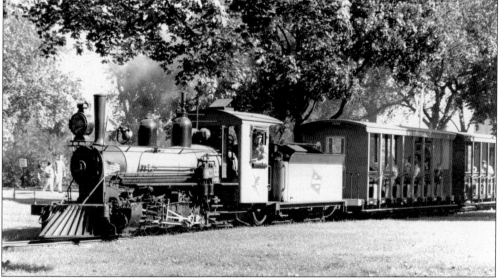

The miniature railway ran a two-and-a-quarter-mile perimeter around the entire park. The scenic ride aboard the Brookfield, Salt Creek, and Western Railroad was a favorite with zoo guests. But the operating expense involved in keeping the train running was ultimately too high, contributing to the decision to discontinue the train rides in 1985. The original *Blue Goose* Chesapeake and Ohio Railway locomotive No. 242 can be seen at the Hesston Steam Museum in northwest Indiana. The original train depot, renovated as the North Gate Snack Shop, is located just east of the Australia House.

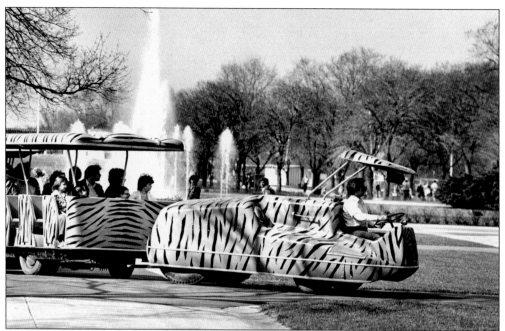

Decorated in colorful animal print patterns, the rubber-tired Motor Safari tram offered a 45-minute narrated tour. From early spring through late autumn since the 1960s, guests have enjoyed the easy mobility and educational experience that the Motor Safari has provided, gliding them through the zoo's 216 acres.

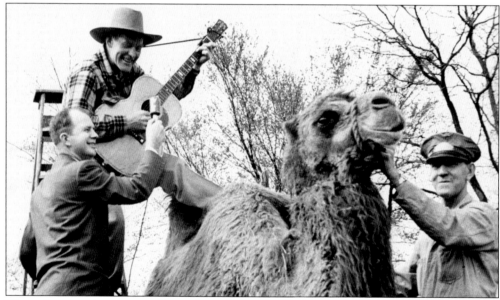

These Bactrian (two-humped) camels with keeper Cliff Jones (right) are standing patiently during a country western radio performance. Since they can be found in and around the Gobi Desert region of China and Mongolia, noted for extremes in temperature, they can adapt to Chicago's variable climate. These camels can drink 29 gallons of water in 10 minutes. Their humps do not contain water, however, but fatty tissue that can be converted into energy on long trips. Today fewer than 1,000 Bactrian camels exist in the wild.

During the first three and a half decades, animal feeding was never prohibited. In fact, a popular guest pastime was hurling marshmallows by the hundreds into the Bear Grottos. Zoo visitors enjoyed watching the animals "begging." On July 17, 1969, when a sudden, torrential downpour flooded the moats in front of the bear enclosures, seven bears swam out and escaped. The bears-on-the-loose tore open a concession stand, helping themselves to marshmallows and other treats.

The seven escaped bears were all rounded up without causing harm to themselves, other animals, or visitors. Here firemen are draining the flooded moats in front of the Bear Grottos. The zoo opened at midday the next day—this being the first time in Brookfield Zoo's history when the grounds were not open all day. In 1970, the sale of marshmallows was discontinued. In 1971, a children's book about the episode called *The Marshmallow Capers* by Gloria D. Miklowitz was published.

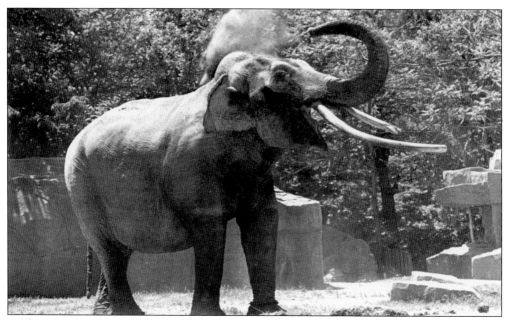

At the time this photograph was taken in 1972, Ziggy the elephant had attained a cult following in the Chicagoland area. After a massive media crusade to move the popular elephant (thousands of schoolchildren sent in pennies, nickels, and dimes), Ziggy was finally released into a special outdoor yard in 1973 amid much fanfare. Unfortunately, the beloved elephant accidentally fell into his exhibit moat in March 1975 and died several months later. He was 55 years old.

Archie, a 32-foot duck-billed anatosaurus was one of a series of Sinclair Oil dinosaurs displayed at the 1964 New York World's Fair. The herbivore had over 2,000 teeth and lived 70 to 80 million years ago. A gift to the zoo when the exposition closed, Archie stands in the heavily wooded west section near Indian Lake and has been enjoyed for nearly five decades.

Brookfield Zoo has led okapi conservation since the species' first North American birth took place here on September 17, 1959. The calf, Mr. G., was born to Museka and Aribi. The timid and elusive okapi, like its relative the giraffe, has distinct markings. Okapi, native to the Democratic Republic of the Congo, had never been seen by nonnative people until the early 20th century. The okapi can be seen in the Habitat Africa! exhibit. (Photograph by Ralph Graham.)

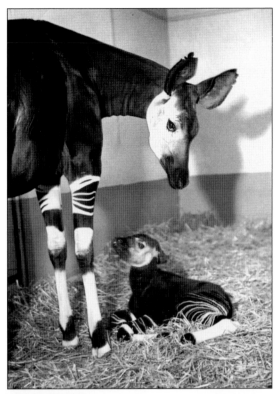

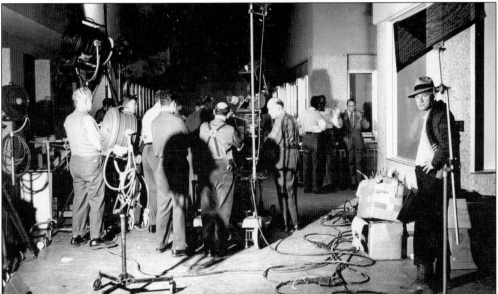

During the 1950s, there was frequent live television coverage of various Brookfield Zoo activities and events. The zoo recognized the tremendous educational influence of the exciting new medium. Television broadcasting was quite complicated, however, involving much equipment and lighting that had to be transported and arranged. In this film noir–like 1958 photograph, an episode of the WTTW Channel 11 series *Discovery at the Brookfield Zoo* is about to be broadcast live.

This photograph, taken in the Aquatic Bird House by Leland La France, was featured in the 25¢ Brookfield Zoo guidebook in the 1950s. This unusual, ashy gray shoebill, named Bubbles, comes from central Africa, where they live in marshy areas. Its huge beak, shaped like a wooden shoe, gives the bird a crocodilian aspect.

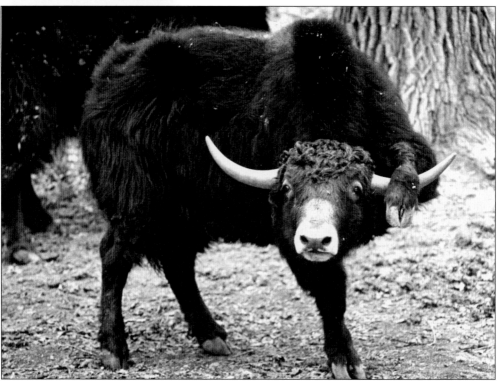

Leland La France often won the Annual International Zoo Photography Contest. The Chicago Zoological Society wisely hired him as the official staff photographer in the mid-1960s. La France's subjects were wide ranging, including a series of images of the yaks. Despite their bulk, yaks are remarkably agile, sure-footed climbers. These long-haired bovine herd animals tend to live at high altitudes in the Himalayan region of south-central Asia. Their thick, shaggy coats insulate them from the cold.

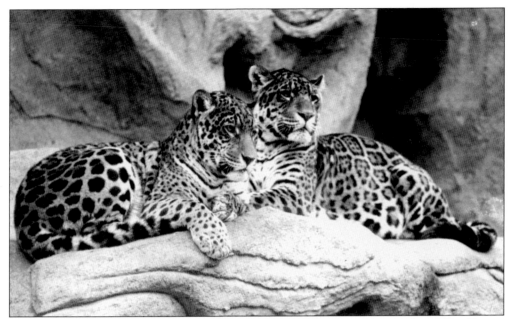

This regal pair of Brazilian jaguars were much admired by guests during the 1960s. Known in Central and South America as *el tigre*, the jaguar is the largest New World cat. They are versatile felines—excellent swimmers, runners, climbers, stalkers, and hunters—and live in the rainforest.

During the WPA days in the Great Depression, a variety of directional signs were carved in fir, painted, and finished in protective lacquer. Here, in the late 1970s, zoo worker Sam Memishi refreshes and refurbishes the signs. There are 25 surviving signs for guests to view in the Holding Theater of the Discovery Center as well as one unpainted ape maquette featured in the main lobby.

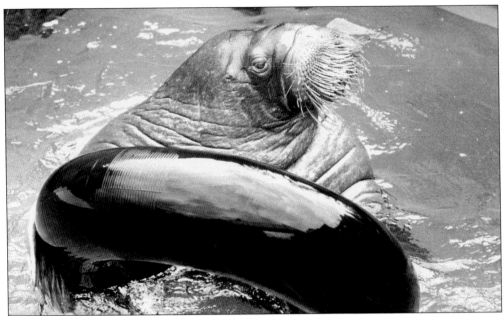

Olga arrived from the Copenhagen Zoo in 1962 as a one-year-old. Weighing nearly 3,000 pounds, Olga, the most expensive animal in the zoo to feed, ate between 45 and 60 pounds of seafood per day ($60,000 worth of fish a year). Olga lived at the Seven Seas Panorama from 1962 to 1988 and hammed it up for fans and would delight in spraying unsuspecting guests with water if they ventured too close to the railing. A bronze sculpture honors her today.

Visitors have always enjoyed the vast expanse of Brookfield Zoo. These folks are strolling past the Refectory Pool ("goldfish wishing pond") on the east mall in 1961. The long walkways between exhibits offered views of the beautiful central Roosevelt Fountain, flower gardens, and the large wooded park on the west side of the zoo.

# *Four*

# CHANGES AND CHALLENGES

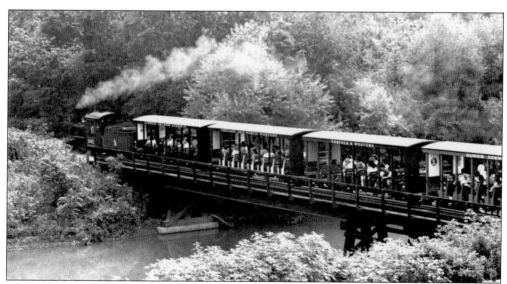

This 1974 image shows the *Blue Goose* locomotive No. 242 hauling the zoo line train packed with guests over Salt Creek Bridge, heading into what was called the Western Frontier of Brookfield Zoo.

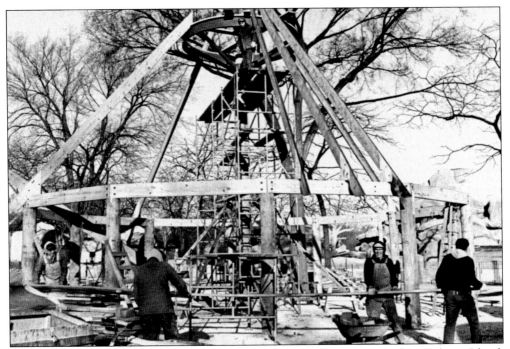

Nyani Lodge, an eatery located in the southeastern part of the park across from Baboon Island, is seen here under construction in 1971. The structure was inspired by central African building designs. The term *nyani* is Swahili for "baboon."

In this view, baboons are looking curiously toward two safety guides and the zoo's security chief, Don Grossling (right). Safety guides stationed around Baboon Island helped regulate the crowds and acquaint the visitors with the new no-feeding policy, which took some getting used to by guests.

Nyani Lodge has been a popular snack site since it first opened in the early 1970s. It is a favorite hangout for student groups, adult guests, volunteers, and zoo staff.

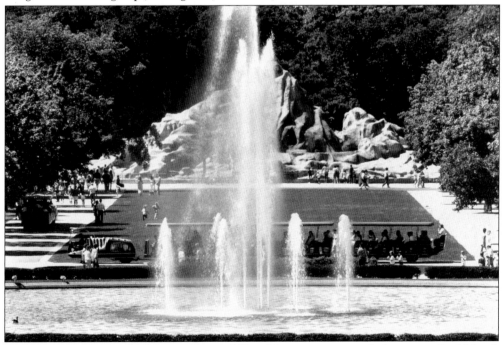

This panoramic image looking west toward Ibex Mountain, previously known as Seal Island, captures a busy Sunday afternoon in July 1980. Note the Motor Safari tram passing north to south just beyond the Roosevelt Fountain.

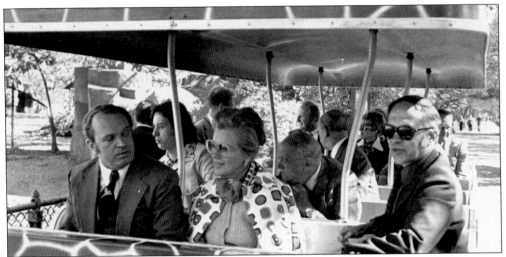

Each of the three-car Motor Safari vehicles was covered with animal skin designs. Seen here in 1975, the guests on this tram, painted with typical giraffe markings, are enjoying a guided zoo tour narrated by zoo director Dr. George Rabb (in sunglasses). He was hired by the Chicago Zoological Society as the first curator of research. A year after this photograph was taken, he became the director of the Brookfield Zoo.

Since the early 1960s, Brookfield Zoo has featured 11 different Mold-A-Rama machines operating at various sites throughout the park. Once coins are inserted (25¢ originally), molten polyethylene plastic is pumped through a pipe into an animal mold. Next, another pipe blows cold air to force the plastic into the crevices of the mold. Then hoses pump automotive antifreeze to cool down the mold quickly. Still popular after five decades, the 11 kitschy, get-'em-while-they're-hot Mold-A-Rama toys include a brown camel, a yellow lion, a black rhinoceros, a white polar bear, and an orange walrus.

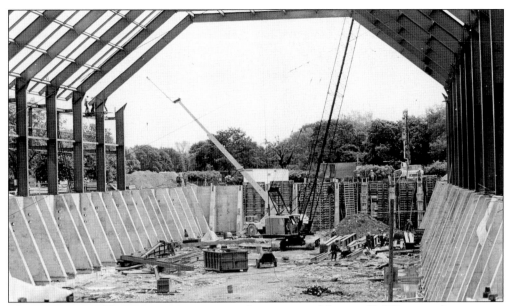

The crane pictured here puts into perspective the vastness of the new 52,250-square-foot primate exhibit under construction in the 1970s. Tropic World would become the world's largest zoo building. The super structure could encompass two football fields when finished. The first fully indoor simulated tropical rainforest, it featured monkeys, apes, pygmy hippopotamuses, otters, birds, and other rainforest fauna cavorting in a realistic setting of rocks, trees, shrubs, thunderstorms, waterfalls, and pools.

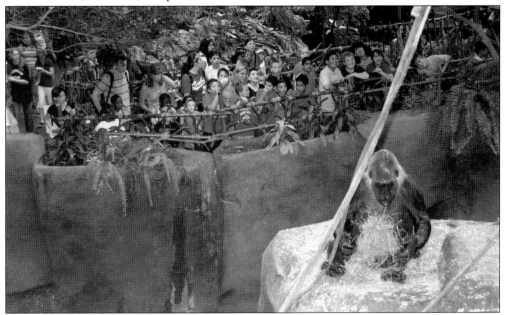

Alpha, a western lowland male silverback gorilla in his 30s, is sorting through straw as part of the Chicago Zoological Society environmental enrichment program. The program stimulates the zoo animals physically and mentally with special items and food, encouraging them to exhibit natural behaviors. At treetop level, the walkways immerse guests into three distinct rainforests: Tropic Africa, Tropic Asia, and Tropic South America.

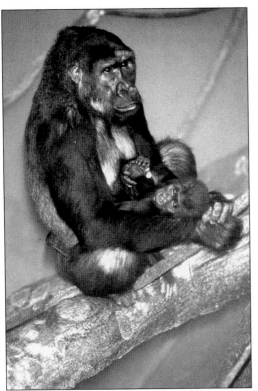

Binti Jua, a western lowland gorilla pictured here with female offspring Koola, made headlines globally on August 16, 1996. A three-year-old boy climbed over a barrier planter and railing then tumbled down to the bottom of the ravine into the gorilla habitat. He suffered a concussion, a broken hand, plus facial abrasions and cuts. Binti Jua, with Koola on her back, picked up the unconscious human child, cradled him, and then carried him 50 feet to the keepers' access door. Binti Jua was honored as *Newsweek*'s hero of 1996 and was designated by *People* magazine as one of the 25 most intriguing people of the year.

By the 1980s, the 10-acre western section of the zoo was known as the Salt Creek Wilderness Preserve, and the man-made body of water was named Indian Lake. These men are testing lake water quality. Indian Lake has been home to trumpeter swans and several species of waterfowl, as well as turtles, bullfrogs, and fish.

Boo! At the Zoo, an annual Halloween "spooktacular" festival, has been a popular event since the 1980s. Activities include professional pumpkin carving; haunted hayrides; spook house tours; a costume parade; zookeeper talks featuring frightful creatures like snakes, spiders, and owls; a conservation scavenger hunt; bobbing for apples; and scary storytelling. Visitors usually report having a ghoulishly good time. This popular event continues to draw record crowds.

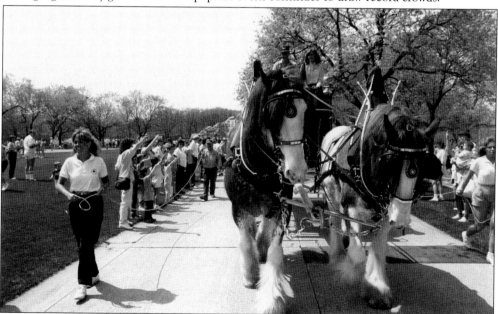

This 1987 Halloween costume parade is led by the zoo's large Clydesdale draft horses. The Clydesdales stood six feet high at the shoulders and weighed between 2,000 and 2,500 pounds each. They were never ridden but pulled wagons, wearing blinders to keep peripheral movement from startling them. Before their retirement, the Clydesdales made frequent guest appearances at local community activities.

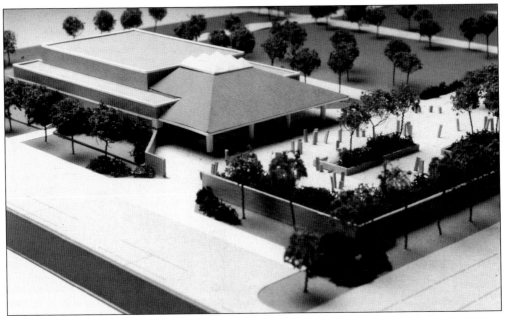

The Discovery Center, seen here in a model, was a 15,700-square-foot space built solely from public donations. It was designed to help visitors get acquainted with the adventure that awaited them at Brookfield Zoo. The Discovery Center also houses the very active education department that produces curricula, modules for teachers, and other instructional materials for hands-on zoo trips. During the school year, over 150 different school groups visit Brookfield Zoo.

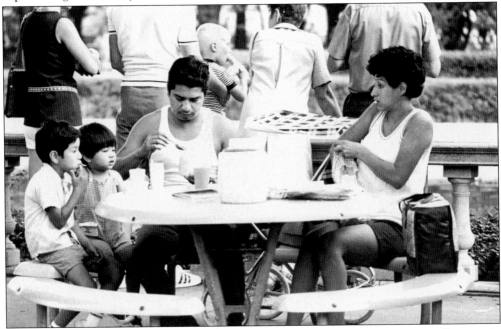

From the very beginning, "a day at the zoo" usually involved eating at some point. Starting in 1934, picnic facilities were located near refreshment stands and restrooms. This 1971 family picnic is taking place in the western section of the zoo. Picnickers also continue to enjoy the terrace just outside the Safari Grill at the end of the east mall as well.

During the 1970s and 1980s, Arctic Island, formerly Kodiak Bear Island, east of the Children's Zoo and Farm was inhabited by a herd of Dall sheep from Alaska. These long-haired white sheep are known for their magnificent curling horns. When bears or other predators approach, Dall sheep flee to steep rocky slopes and crags.

Due to the overwhelming popularity of the dolphin show, the new Seven Seas Panorama was built to accommodate larger crowds. The location was moved from where Living Coast stands today to the eastern side of the zoo in the mid-1980s.

The Giraffe House, constructed in the 1930s and pictured here in 1980, welcomed millions of Brookfield Zoo visitors over the decades. Renovations of the old Giraffe House would become the first phase of the ambitious Habitat Africa! exhibit opening in 1993 designed to present giraffes and many other African animals in a naturalistic savanna waterhole setting without obvious barriers.

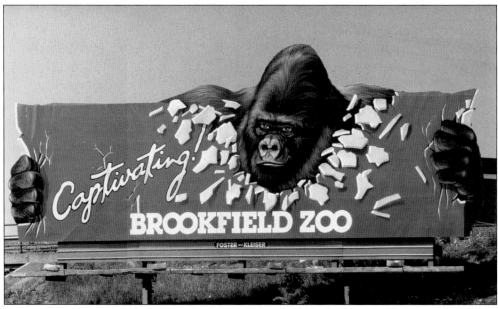

During the 1970s and 1980s, a variety of provocative, dramatic billboards advertising Brookfield Zoo were displayed at prominent points throughout Chicago—along highways and expressways as well as train and elevated lines. This one features Samson, a much-beloved western lowland silverback gorilla.

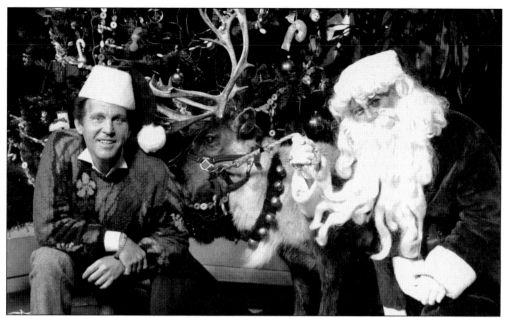

Holiday Magic debuted in 1982 and was a roaring success. During the first year, the park was transformed into a fantasyland for five special evenings, attracting 58,000 visitors. Carolers sang on the Motor Safari trams, which traveled from the South Gate to Olga the walrus. Bobby Minton, born in 1935, was in Chicago promoting his new Christmas album *Santa Must Be Polish*. He is seen here posing for a photograph in 1987 with Santa Claus and Hilde the zoo reindeer.

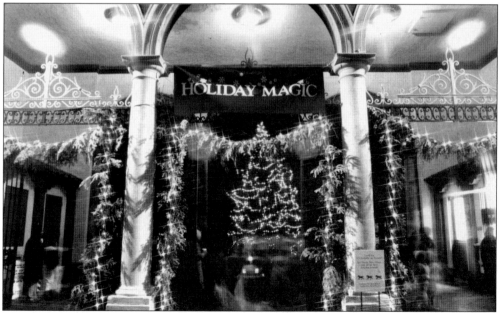

Every December, Brookfield Zoo becomes a winter wonderland of dazzling lights and holiday excitement, as seen at the South Gate in 1994. Festival activities now include costumed characters, professional ice-carving demonstrations, magicians, musical performances, laser light shows, and singing to the animals. In 1996, over 95,000 attended Holiday Magic. In 2008, the zoo was glowing with over one million lights decorating the trees and shrubbery.

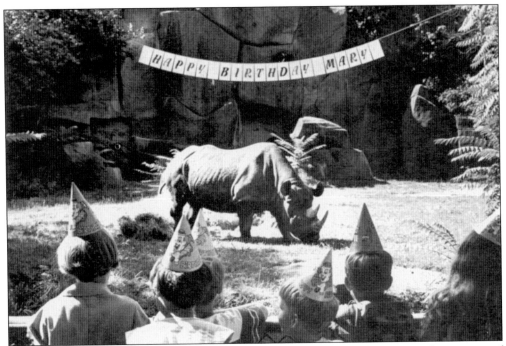

Children are joining Mary the black rhinoceros's 45th birthday celebration in the summer of 1978 at the south side of the Pachyderm House. Radio personalities from WGN helped host the festivities.

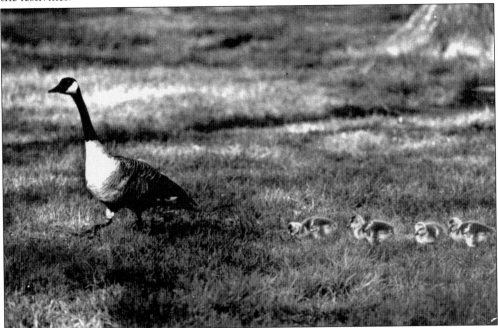

By 1970, Canada geese were widely observed grazing and meandering on Brookfield Zoo lawns, flying over the park, and attending to their offspring. Each March, the highly sociable Canada geese can still be seen courting, building nests on the park grounds, and defending their territories throughout the zoo.

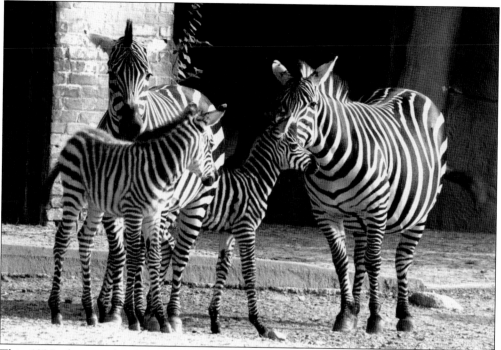

This 1990 photograph of Grant's zebras taken by Mike Greer highlights their remarkable coloration. Their stripes serve as camouflage when the animals are in tall grass. In shimmering heat, the stripes blur and break up the zebra's profile, thus confusing predators. The endangered Grevy's zebras can also be found in Hoofed Animals.

The extremely popular Music at the Park concert series showcasing bands such as the Beach Boys, Three Dog Night, Aerosmith, and Chicago drew sell-out crowds during the 1970s and 1980s. This photograph was taken at country western night, featuring Kenny Rogers. The concerts were staged on the grassy open mall adjacent to the Pachyderm House.

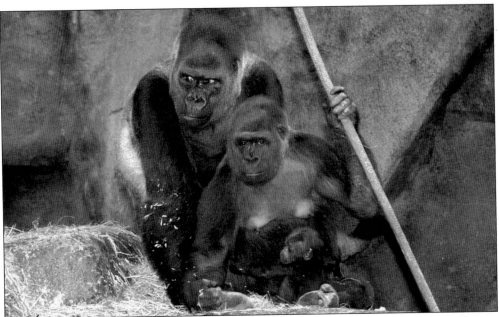

Seen here with Ramar (left), a star resident of Tropic World, is Baracka and their offspring Nadaya, which means "first" in Hausa, a Nigerian dialect. The male gorilla was born on April 4, 2000. Ramar formerly had a stage career with animal trainer Jack Badal as a performing gorilla. In 1998, at age 29, he was moved to the Chicago Zoological Society from North Carolina Zoological Park for breeding purposes.

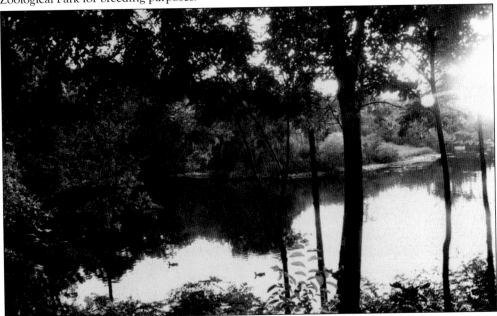

When visitors hike the nature trail they have the opportunity to connect with this region's picturesque environs in the western end of the park. Growing in this area of the zoo are both large and small trees native to the region, including species of oak, numerous ash, linden, elm, hackberry, hickory, black cherry, hawthorne, prairie crab, and many others. Several of the largest burr oak trees are thought to be nearly 200 years old.

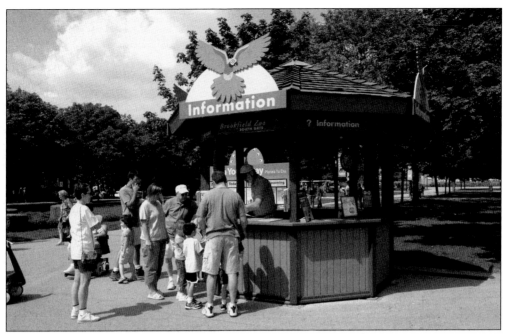

Over 500 friendly, knowledgeable volunteers donate their time to the zoo in many capacities. The Brookfield Zoo Volunteer League was first launched in 1970. Here is one of two green and orange information kiosks, located just inside the South Gate (the other is adjacent to the North Gate), staffed by volunteers.

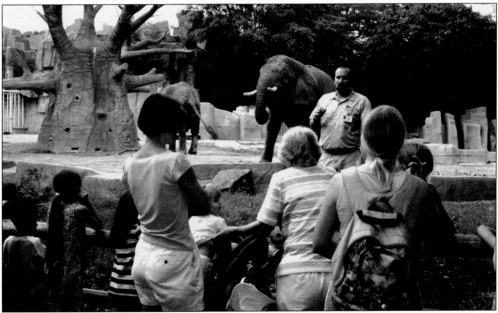

Joe Gusic, senior zookeeper, leading a "keeper chat," is answering questions about the animals under his care and sharing various stories and anecdotes. The chats became an immediate hit with visitors in the 1980s. In the background of this contemporary photograph are two African elephants, Christy (tail) and Affie (tusks). The short daily presentations were so well attended the schedule was expanded.

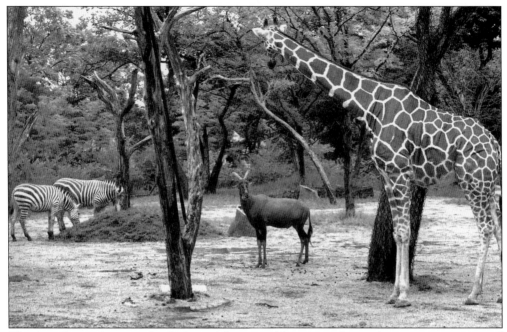

The first phase of spectacular Habitat Africa!—a 35-acre simulation featuring a savanna and water hole called a Kopje (pronounced kah-pee)—opened in May 1993. It featured a more naturalistic setting of mixed species and plants. In 2008, a baby giraffe was born to Franny, fathered by Dusty.

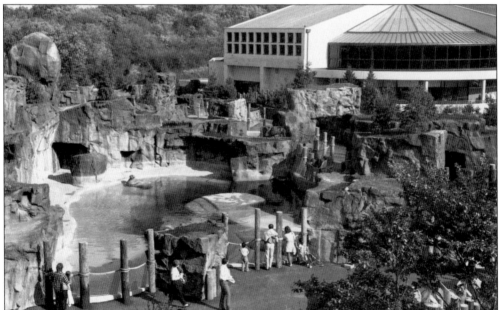

Since 1987, walruses, seals, and sea lions have inhabited a rocky seascape exhibit called Pinniped Point, adjacent to the Seven Seas Panorama. Pinnipedia is an order of carnivores concentrated in the polar seas. Pinnipeds have limbs adapted to aquatic life with webbed flippers. Visitors to Pinniped Point can watch the seals and sea lions from a rocky path or from windows beneath the exhibit.

Samson's fans are watching the western lowland silverback gorillas relaxing in the treetops of the African rainforest section of Tropic World. Since his death in the late 1980s, a striking life-size bronze sculpture of Samson continues to provide a photo opportunity for young guests at the entrance of the building.

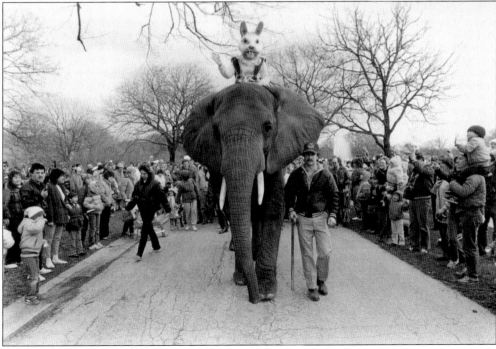

In 1985, crowds were thrilled to see Affie the elephant with the Easter Bunny in a zoo parade during spring Eggcitement.

The Chicago Zoological Society offers a progressive series of educational programs for youth called the Career Ladder. Children and young adults "climb" the ladder while exploring science careers. These three teens are comparing animal skulls before they go out into the zoo with their Roving Naturalist carts. Internationally, the Chicago Zoological Society sponsors the Global Conservation Leadership Program in Guyana.

Scientists believe that during World War II, brown tree snakes were inadvertently introduced to the island of Guam as military cargo stowaways. By 1983, researchers realized the snakes were decimating the Micronesian kingfisher populations by eating not only rats and mice but the birds and their eggs as well. To save the species, scientists captured 29 of the remaining kingfishers and placed them in zoos. This was none too soon because by 1988 there were no more kingfishers in the wild. This distinctive, bright rust and cobalt blue bird can be seen in the Perching Bird House.

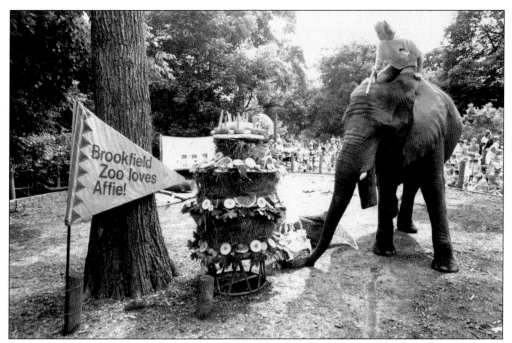

Affie, the beloved 9,520-pound African elephant, turned 20 in 1990. Her birthday cake, seen here, was made of hay and fruits. The candles were carrots.

Pictured here is Zhana, a Bactrian camel, with calf Rusty, a male born on February 28, 2008. One month later, Kristina gave birth to Gobi II, a male, on March 22. They were both sired by Russell and were the first Bactrian camel births at Brookfield Zoo since 1990. Sadly, Russell was euthanized due to declining health before the calves were born.

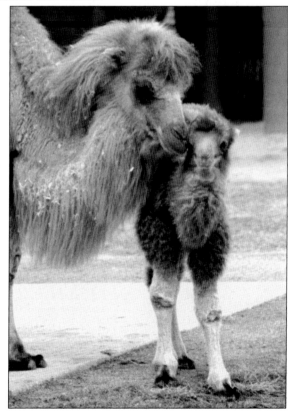

The Chicago Zoological Society has a number of award-winning educational programs fostering young conservation leaders via internship opportunities. In Feathers and Scales, Sean Rauen, now a keeper, is feeding a piece of soft fruit to a toucan. The toucan's huge but lightweight beak enables the bird to reach out to pluck fruit from branches.

Zoo guests are drawn to the Hamill Family Play Zoo by the beautiful ringtailed lemurs enjoying the morning sun. In their native Madagascar habitat trees, the females dominate in the selection of mates and food. The Hamill Family Play Zoo was formerly the Small Mammal House and underwent renovations, winning the Association of Zoos and Aquariums 2001 Exhibit Award for its innovative design. It allows children to play and experience the environment and animals, and that inspires them to develop caring attitudes toward the natural world.

Cautiously peering around some rock work to investigate their new yard on their first day at Brookfield Zoo are Hani and Paji, two sloth bear sisters, who came from the Capron Park Zoo in Attleboro, Massachusetts, in 2004. Now considered threatened, sloth bears in the wild primarily live in the forests of Sri Lanka and India. A favorite pastime of sloth bears is grubbing and snorting insects. The four-year-old sisters Hani and Paji had a feeding free-for-all during the cicada influx in the summer of 2007.

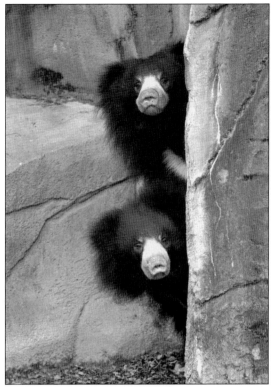

The rocky shores of the Living Coast exhibit can be seen in this 2001 postcard view. In the wild, Humboldt penguins are threatened with extinction because of overfishing and habitat loss. The Chicago Zoological Society/Chicago Board of Trade Endangered Species Fund provides ongoing support of the important Humboldt penguin research conducted by the Chicago Zoological Society's Dr. Jennifer Langan in South America.

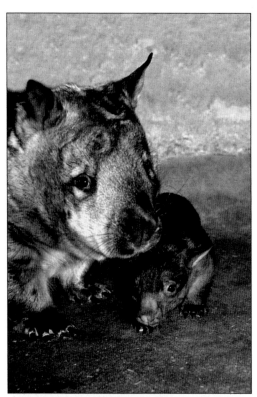

The southern hairy-nosed wombats live in central and southern Australia. Their sharp, long claws dig warrens, complex underground tunnel systems. Pictured here in 2006 is infant Goldie with mom Kambora. Goldie was sired by Carver (not shown), who is regarded as possibly the oldest living wombat in captivity. The zoo has been involved in wombat conservation projects since 1971.

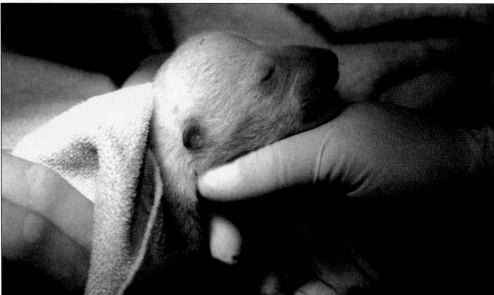

Polar bear Arki gave birth to two female cubs on October 30, 1999. But Arki stopped caring for her young for unknown reasons. The newborn bears were removed for emergency hand rearing. One surviving cub, Tiguak, which means "adopted" in Eskimo dialect, was kept warm in an incubator. Later Tiguak was introduced to Eddy, from Canada's Aquarium Jardin Zoologique du Quebec, to learn how to be a bear. They both were later transferred to the Aquarium du Quebec in 2002 as part of the polar bear species survival plan.

Since 1989, Brookfield Zoo has conducted the world's longest running study of a dolphin population. The Sarasota Dolphin Research Program is headed by Dr. Randall Wells (far right), a renown conservation scientist. The program studies the ecology, health, and life patterns of a resident community of bottlenose dolphins in Sarasota Bay, Florida, spanning five concurrent generations. In this image, visiting scientists from China and Argentina are gaining conservation expertise by working with Dr. Wells.

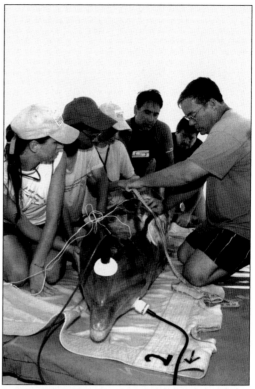

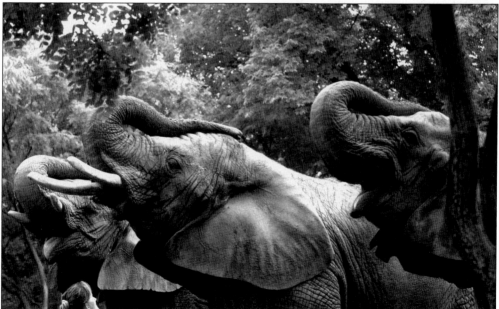

African elephants Mame, Affie, and Christy continued to be favorites of many guests in the 21st century. Christy has no tusks, a normal if not widespread variation for her species—similar to being born without wisdom teeth. The 40,000 muscles in an elephant's trunk enable a high degree of dexterity—elephants can use their trunks to pick up an object as small as a coin. In 2008, Affie was 38 and Christy turned 30 years of age.

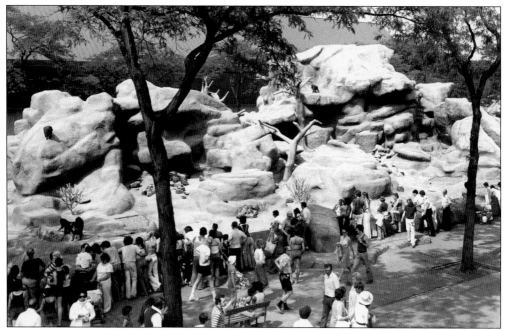

Baboon Island has provided hours of interesting viewing for young and old zoo guests over the years. The structure was 70 years old in 2006. Since 1985, the Chicago Zoological Society has been involved in baboon research both in Kenya and at Brookfield Zoo, monitoring and comparing the large, closely knit family groups in both settings.

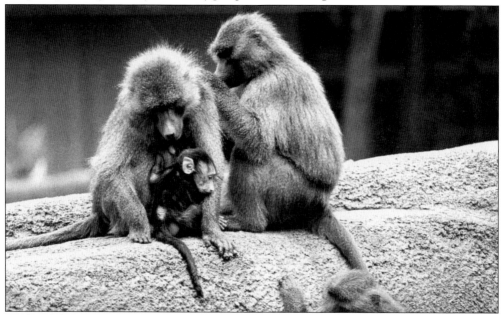

Mother baboons carrying babies are often groomed by other females. This socially cohesive behavior, which involves picking through and removing parasites from fur, helps keep the group together. This photograph was taken by Mike Greer, the zoo's official photographer from 1980 to 1996. His images have appeared in *Newsweek*, the *Living Bird*, the *Wall Street Journal*, and *AZA Communique*.

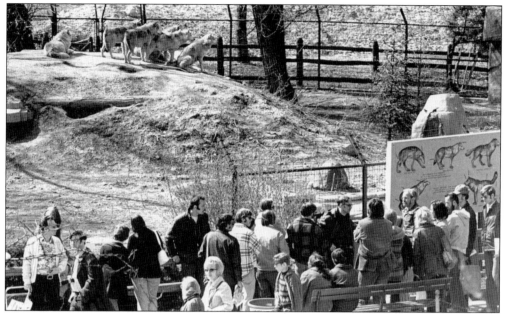

During the 1970s, Wolf Woods was constructed. The timber wolf pack is looking into the distance toward the keepers on the high mounds for good viewing and lots of space to run and explore. Note the large educational sign outside the exhibit that provided an explanation of the animals' basic behavior patterns. Wolves are among the most social of all animals. In the wild, their packs may be as large as 20 animals.

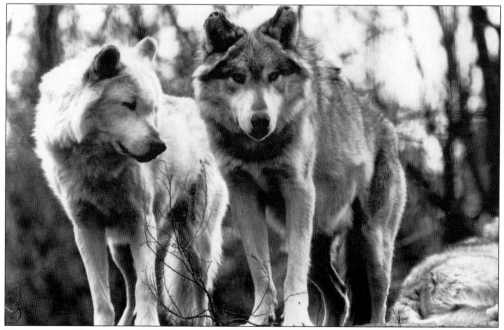

The spacious Regenstein Wolf Preserve exhibit constructed on the wooded western end of the zoo in June 2004 allowed guests to experience the wolves in a naturalistic setting. In the wolf social structure, there is usually an alpha or boss male to whom all the others give way. Nearby residents bordering the zoo may hear the wolves howl in response to local sirens.

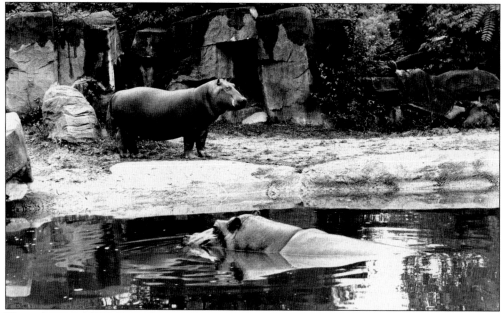

The submerged Nile River hippopotamus is doing what hippopotamuses do best. They have strong pillarlike legs to support their great weight. Their eyes, ears, and nose are at the top of their head, allowing them to be nearly totally submerged much of the time. They spend their days in the water and travel at night on land to feed. The term *pachyderm* comes from the Greek word *pachydermos*, meaning "thick skinned."

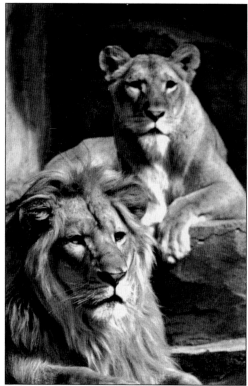

Since the establishment of Brookfield Zoo, lions have been important. Lion populations around the globe are diminishing at a rapid rate due to habitat loss, agricultural threats, and poisoning by farmers. This pair of lions is seen in a postcard image in the early 1990s. In the wild, these social creatures live in close-knit, long-term bands or prides of a dozen or so. Generally, the lioness does the hunting, although a male may help in setting up an ambush.

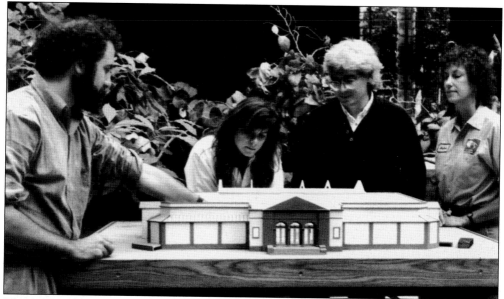

This 1993 model displays the much-anticipated naturalistic exhibit the Swamp, a renovation of the early-1930s Primate House, which was originally built for $175,000 during the depths of the Great Depression. From left to right, Tim Sullivan, Marty Sevenich, John Scott Foster, and Andrea Zlabis are exploring the possibilities of the Swamp, which would allow visitors to explore some of North America's wetland wonders. The exhibit would feature wildlife from crawfish to otters and egrets to alligators.

Once the 65-year-old building had been transformed into a naturalistic, multispecies display, visitors found it difficult to tell the difference between the natural and man-made elements within the Swamp. While the rocks seen here were created by humans, Gaston the alligator is the real thing.

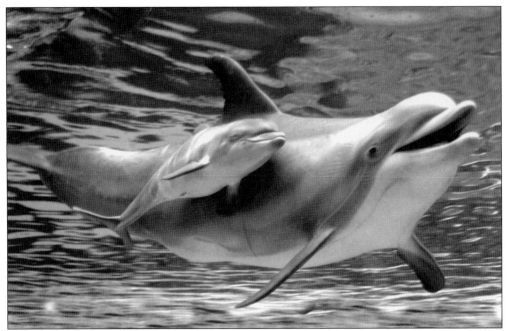

This beautiful image, taken by zoo photographer Jim Schulz, shows the new dolphin mother and blissful infant at the Seven Seas Panorama. In the 1990s, the zoo gained prominence as a center for various types of conservation programs: population genetics, animal nutrition, behavioral studies, and ecological restoration.

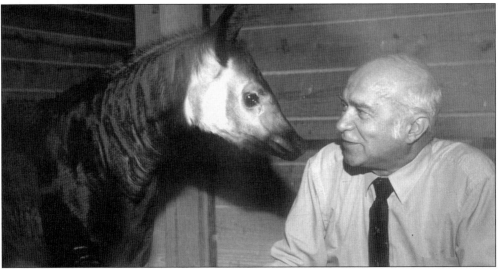

The arrival of a rare female okapi to Brookfield Zoo coincided with the appointment of Dr. George Rabb as curator of research on the same day back in 1956. Today a world-renowned figure in animal welfare and conservation, Dr. Rabb served as chairman of the Species Survival Commission of the World Conservation Union, created the Declining Amphibian Population Task Force, and was a leader in the development of the World Conservation Strategy. Rabb and his wife Mary, who was zoo librarian for 40 years, conducted pioneering studies of wolf behavior during the 1960s. He served as the Brookfield Zoo director from 1976 to 2003. Dr. Rabb is seen here in 2001 with an okapi.

*Five*

# NEW DIRECTIONS

Young guests enjoy their ride on the giant carousel that opened Memorial Day weekend in 2006. There are no horses, as usually featured on merry-go-rounds. Instead there are 72 hand-carved, hand-painted animals ranging from the camel and the dolphin to the manatee and the polar bear. In peak season, the carousel hosts up to 5,000 riders per day.

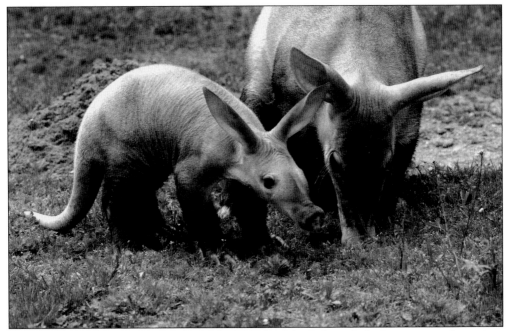

The aardvark, or "earth pig," inhabits Africa south of the Sahara. It feeds on ants and termites. Here Rachaael (left), a female aardvark calf born on March 21, 2004, is seen with her mother, Gracie. Visitors enjoyed glimpsing the mom-calf relationship. Gracie had three previous offspring. The entire North American captive aardvark population numbers only 25.

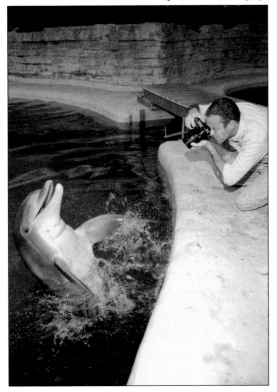

Jim Schulz, the extraordinary award-winning photographer for the Chicago Zoological Society for over 20 years, started his Brookfield Zoo career as many people do—as a volunteer. His photographs appear in official zoo publications. He captures the beauty, individual characteristics, and emotions of all the animals at the zoo. Here Schulz is seen photographing Tapeko, a bottlenose dolphin at the Seven Seas Panorama.

Seen here on a winter day outside the Fragile Kingdom in 2004 is Robeki, an Amur tiger. Most of its wild prey consists of hoofed animals, but the tiger's diet can range from bears to snakes. For all their great strength and stealth, tigers only catch a meal 1 out of every 15 tries. Like all tigers, the Amur is highly endangered. In the wild, its size and strength do not guarantee its safety. Each year these powerful, graceful cats lose more habitat in their Asian homeland.

In 1995, after a mother bear was killed on Admiralty Island, Alaska, her orphaned twin Alaskan brown bear cubs were living in a garbage dump. They were rescued and brought to Brookfield Zoo. The popular duo, Axhi and Jim, continue to amaze guests with their active swimming and playing. They were named for their keepers, Axhi Dardovski and Jim Rowell.

Like the Living Coast, the Swamp exhibit connected people with nature in a variety of meaningful ways. Here Nicole Antol, a member of the grounds crew, cleans the area near Gaston the alligator. Exhibits, design, HVAC, carpenters, painters, plumbers, electricians, information services, welders, food service, catering, and grounds crew members work hard every day to provide an optimal experience for Brookfield Zoo guests.

This unique-looking giant anteater named Velcro has a very long 24-inch tongue that makes insect eating easier by flicking back and forth 150 times per minute. Guests can view this remarkable creature in Tropic World. In 2009, Velcro is 11 years old.

Nearly 300 volunteers and 300 docents served as park greeters and exhibit guides in the early 21st century, playing an important role in educating guests and advancing conservation leadership. Marilyn Volek is seen here with a special cart displaying touchable animal props. Brookfield Zoo's education department has a collection of over 4,000 biofacts to share with visitors, including bones, skulls, quills, teeth, antlers, claws, hides, shells, and horns.

The Chicago Zoological Society is a participant of the Species Survival Plan, a conservation and captive wildlife management program for 116 endangered species established in 1981 by the Association of Zoos and Aquariums. Brookfield Zoo has 44 species from this list, including black rhinoceroses. During the early 21st century, trade in rhinoceros horns continues to the further decline of this seriously endangered species.

Senior zookeeper David Grubaugh gives some young guests in front of the Reptile House an up-close look at a snake. Although it was always one of Brookfield Zoo's most visited exhibits, in 2005 the aging building closed its doors, with many of its reptile and amphibian residents moving across the pond into the 2,000 square feet of space in the former Aquatic Bird House that had been revamped as Feathers and Scales.

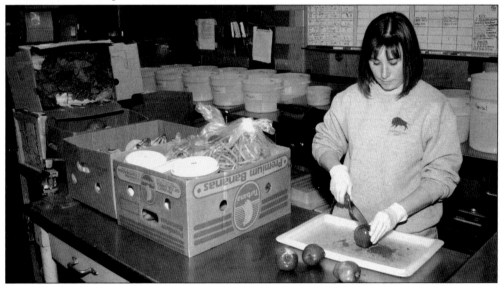

In the early days, little was known about the dietary needs of zoo animals. Brookfield Zoo became the only zoo in the world with a comprehensive nutritional program when the Zoo Nutrition Network was founded in 1994. Wendy Cimino—senior zookeeper, commissary—is seen here chopping apples. Since animals' diets are often extremely specialized, research helps address each animal's nutrition needs. One result of careful diet control is that animals in captivity almost always live longer—sometimes more than 10 times longer—than they would be expected to in the wild.

Walter the warthog, seen here in 2005, is a member of the pig family. Warthogs are found living in savannahs and grasslands of eastern and southern Africa. The heavy folds of skin on the cheeks and the extended skin or "warts" distinguish them from other hogs. They are surprisingly light on their feet. Their snout acts like a shovel. Unfortunately, as readers may remember from Disney's *The Lion King*, warthogs are a favorite food of lions.

These excited guests are watching Corky the walrus at Pinniped Point. The walrus is the largest pinniped species living in the Arctic. The melting of sea ice due to climate change has threatened the walrus population in the past decade.

Beginning in 1995, the nature trail around Indian Lake included various hands-on activities and guides to identifying the native birds, plants, and mammals that visitors were likely to encounter. The 10-acre western section of the zoo is now known as the Salt Creek Wilderness.

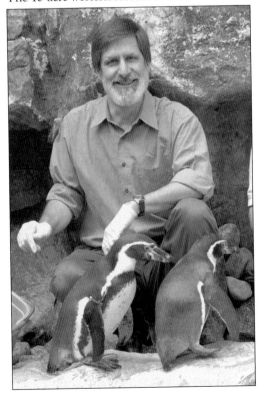

The Chicago Zoological Society has actively been involved with species conservation for decades. Dr. Robert Lacy, a population biologist working here with Humboldt penguins at the Living Coast, made a major contribution to population management recently with the design of MetaModels Manager. This software utilizes computer modeling for the prediction of species extinctions by linking population viability analysis with data for climate change, habitat loss, human social factors, and emergence of disease.

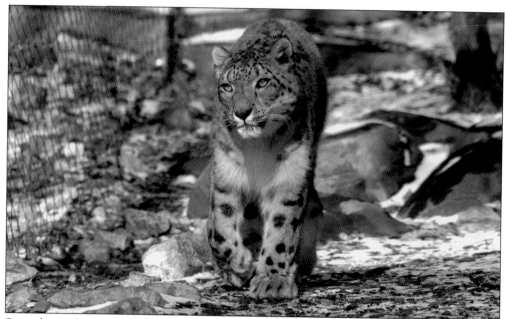

Snow leopards are well adapted to the cold, snowy Himalayan region. They have become endangered due to widespread poaching for their furs. Brookfield Zoo has long participated in a cooperative breeding program among zoos to manage and protect snow leopards. There was netting placed over the snow leopard enclosure because they have such powerful hind legs, they might be able to leap out of their yard. By 1990, zoo animals would still do what comes naturally in terms of breeding, but they were also monitored by "species coordinators" who used sophisticated databases to find mates for individual animals.

Due to habitat loss, the golden lion tamarin, found only in Rio de Janeiro in Brazil, faces extinction. Brookfield Zoo has played a key role in reintroducing zoo-born golden lion tamarins to their native habitat in Brazil, with over 140 tamarins reintroduced since 1984. Golden lion tamarins, so named because of their manes, can be found in Tropic World.

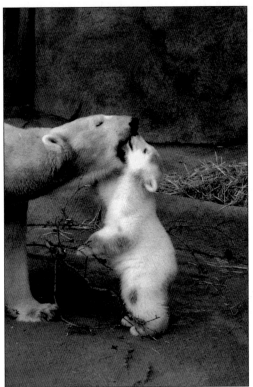

Births at the zoo generate much attention, especially when involving endangered species. This male polar bear cub, baby Hudson, was born to his mother Arki in December 2006. Guests were thrilled to watch his mom teaching Hudson to swim the following summer. Although they are aquatic animals, polar bears do not know how to swim naturally. Polar bears rely on sea ice to hunt for seals, their primary source of food.

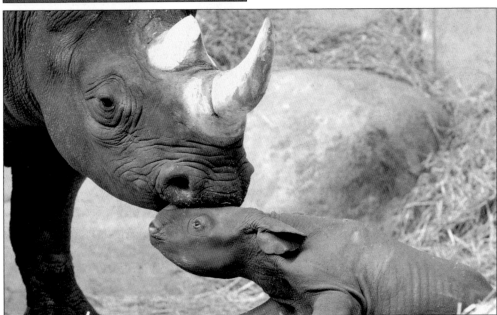

As the zoo focused on wildlife and ecosystem conservation, a key program was the breeding of endangered species. Seventy-pound newborn baby rhinoceros Kianga, meaning "sunshine" in Swahili, is seen here with his 3,000-pound mother, Shima. There was a population of 115 black rhinoceroses in U.S. zoos in 2006. In the wild, poachers hunt the animals purely for their horns, prized as dagger handles or turned into traditional medicines in China.

Beloved Beta (1961–2008) was an amazing primate with a legacy of medical triumphs. She was the first gorilla to give birth to an infant born through artificial insemination (1981) and to receive bilateral hip replacement surgery (1986). In 2007, gynecologists, experienced in performing procedures on humans, were brought in to perform the first-ever documented uterine fibroid embolization, a minimally invasive surgery, on a 47-year-old nonhuman primate—Beta.

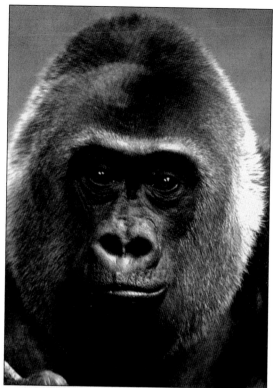

The former Small Mammal House reopened as the Hamill Family Play Zoo in 2001. Its fun activities allow children to build connections with nature and wildlife. Here children can feed animals, role-play as a veterinarian or zoo director, train a dog, or paint their faces like lemurs, zebras, or leopards. The popular attraction was named for Corky Hamill, an influential Chicago Zoological Society chairman. These young guests are examining a frog X-ray.

In 2008, the World Association of Zoos declared the Year of the Frog, and the Chicago Zoological Society created special exhibits and events. Andre Copeland, head of interpretive programs, is captivating young participants and their parents while raising their awareness of the global amphibian extinction crisis caused largely by the chytrid fungus. Many rare amphibians can be seen in Feathers and Scales such as the blue poison arrow dart frog.

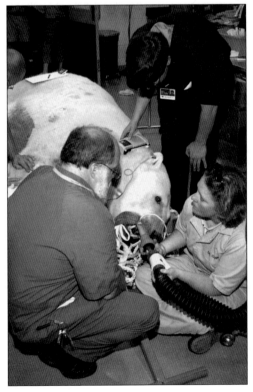

Dr. Thomas Meehan, vice president, Veterinary Services, is preparing male polar bear Aussie for hernia surgery. Brookfield Zoo veterinarians continue to blaze new trails in zoological veterinary medicine.

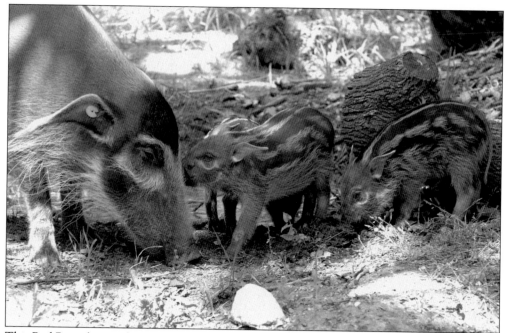

This Red River hog and infants are nosing around in the Habitat Africa! exhibit. Born in 2007, with prominent striping on their backs, they are dark brown and light rust. As they age, only a single white stripe across their back remains. Their hairy ear tufts stick out curiously. They tend to dig for food with their disklike snouts. They live in Africa and Madagascar.

At Brookfield Zoo in the Fragile Kingdom, guests can view the unexpected. In an underground see-through burrow system, the unusual naked mole rats are digging with their long teeth. Highly social, neither moles nor rats, these rodents live in amazing cooperative colonies in Ethiopia, Kenya, and Somalia. On June 15, and June 27, 2008, two separate naked mole rat queens gave birth to 12 pups each.

Thrilled guests watch the roadrunners making their mad dash across the exhibit in Feathers and Scales, an exciting combination of birds, reptiles, and amphibians created in the old Aquatic Bird House on the west end of the Formal Pool.

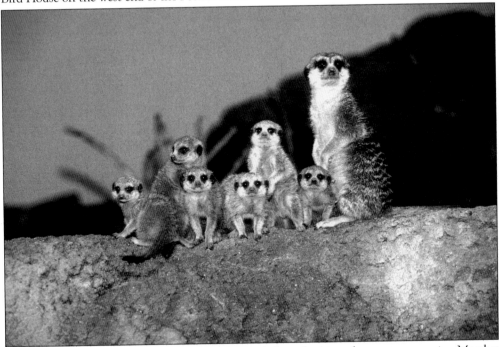

Meerkats gained prominence with the airing of the television documentary series *Meerkat Manor*, beginning in 2007. Brookfield Zoo houses a busy troop of meerkats in the original Lion House, completely renovated in the 1990s as the Fragile Kingdom.

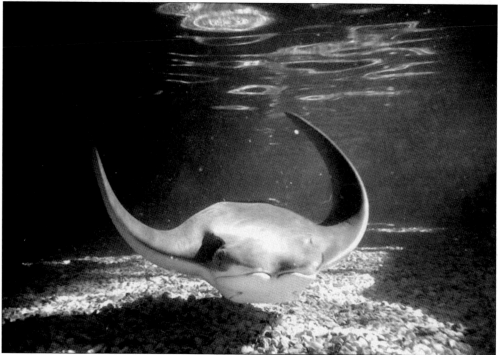

In the summer of 2007, a widely popular traveling attraction called Stingray Bay allowed guests to place their hands into a 16,000-gallon pool and touch a number of velvety cownose and southern stingrays as they "flew" by in the salt water. Stingrays are fishlike creatures that belong in the shark family and like many of their shark relatives are actually calm by nature. The attraction returned in 2008 with the addition of three shark species and a new name—Sharks at Stingray Bay.

The gracious Pavilions took five months to construct during 2007 and 2008. The four separate spaces have peaked roofs in an Asian-influenced architectural style. The Swan, the largest, can seat 500 and is equipped with sides that roll down. Altogether, the Pavilions can accommodate 2,000 guests for weddings, corporate events, and special occasions.

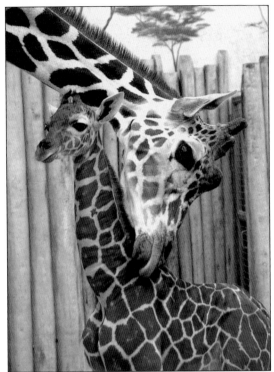

On August 15, 2008, excited guests witnessed the beginning of the marvelous birth of a male reticulated giraffe calf sired by the late Dusty. The mother, Franny, was then moved to a secluded birthing area. When giraffes are born— feet first—they fall five feet to the ground, which galvanizes them into action, and within an hour they can start to stand on their own.

An animal-loving kid who grew up to run one of the world's largest zoos, president and chief executive officer Dr. Stuart D. Strahl arrived in 2003 with 20 years of experience as a conservation leader. He is taking the Chicago Zoological Society (85,409 members in 2008) in new directions such as the Center for Conservation Leadership and the Center for the Science of Animal Well Being (CSAW), internationally recognized programs designed to advance the science of comprehensive animal care, well-being, education, and science. The former president and chief executive officer of Audubon of Florida (pictured with Basilla, a female walrus) is focused on the future.

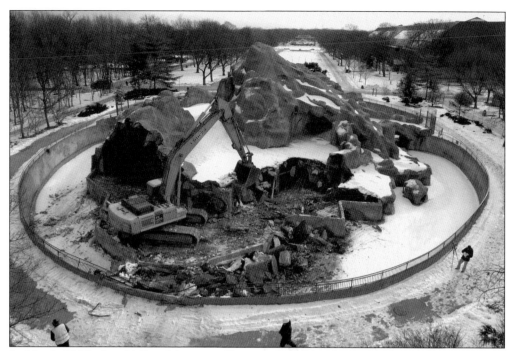

In March 2008, the old Ibex Mountain (formerly Seal Island) was razed to make way for the exciting new $24 million exhibit the Great Bear Wilderness, scheduled to open in late 2010.

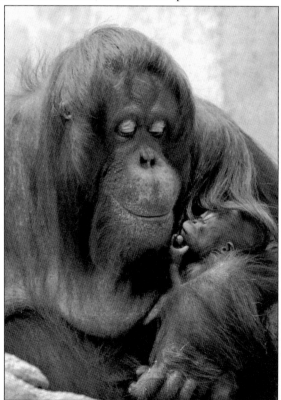

This tender moment shows the caring nature of Sophia, an experienced orangutan mother, who gave birth to a daughter on October 6, 2008. Critically endangered, Bornean and Sumatran orangutans face devastating habitat loss due to deforestation resulting from palm oil plantation development. The Chicago Zoological Society hosted a conference for orangutan caregivers, managers, scientists, and biologists to discuss the first nationwide effort to address the diminishing orangutan population and impact of humans and their behavior on the species in October 2007.

# www.arcadiapublishing.com

MAP SEARCH

Discover books about the town where you grew up, the cities where your friends and families live, the town where your parents met, or even that retirement spot you've been dreaming about. Our Web site provides history lovers with exclusive deals, advanced notification about new titles, e-mail alerts of author events, and much more.

Find Your Place in History.